HELLO
NY

HELLO
NY

AN ILLUSTRATED LOVE LETTER TO THE FIVE BOROUGHS

Julia Rothman

CHRONICLE BOOKS

SAN FRANCISCO

Library of Congress Cataloging-in-Publication
Data available.

ISBN: 978-1-4521-0984-8

Manufactured in China.

MIX
Paper from
responsible sources
FSC® C008047
www.fsc.org

Some names have been changed in this book
to protect the privacy of the individuals
interviewed.

10 9 8 7 6 5 4 3 2 1

Chronicle Books LLC
680 Second Street
San Francisco, CA 94107

www.chroniclebooks.com

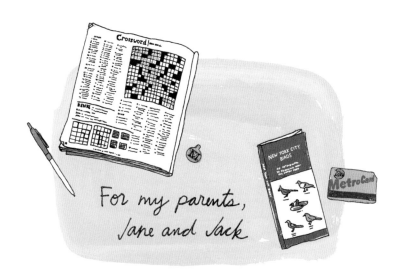

For my parents,
Jane and Jack

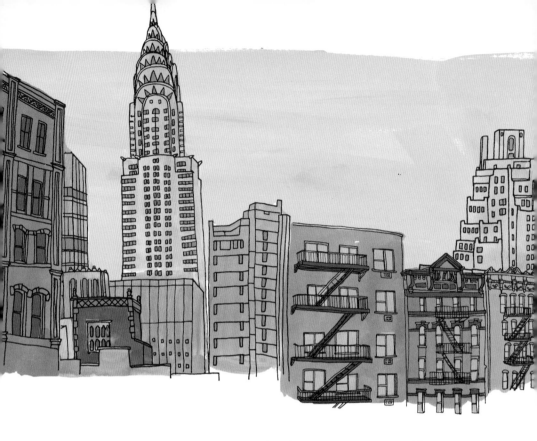

I've often been told "You're so New York!" I never
know if this is a compliment or a criticism.
What does that mean? Neurotic? A fast
walker? Liberal? Straightforward? I have
lived here all my life and will never leave,
so I might never know.

I am comforted surrounded by people, clutter,
culture, noise, and excitement. Walking around
in New York presents a variety of opportunities:
Maybe you'll run into your childhood friend,
with whom you've had no contact for twenty-six
years; maybe you'll come across an organized
pillow fight that fills Union Square; maybe
you'll share a taxi with a man whom you read
about in the newspaper the next day; maybe you'll
try avocado flavored ice cream. (All of these
things happened to me recently.)

I heart NY.

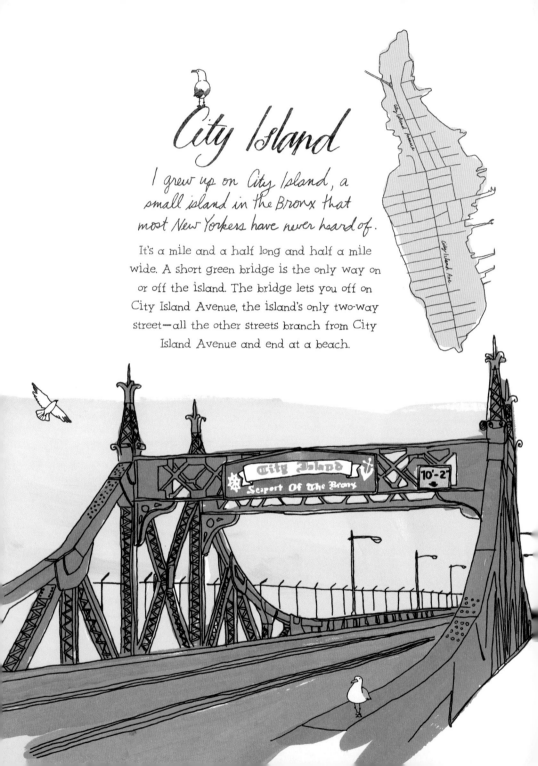

City Island

I grew up on *City Island*, a small island in the Bronx that most New Yorkers have never heard of.

It's a mile and a half long and half a mile wide. A short green bridge is the only way on or off the island. The bridge lets you off on City Island Avenue, the island's only two-way street—all the other streets branch from City Island Avenue and end at a beach.

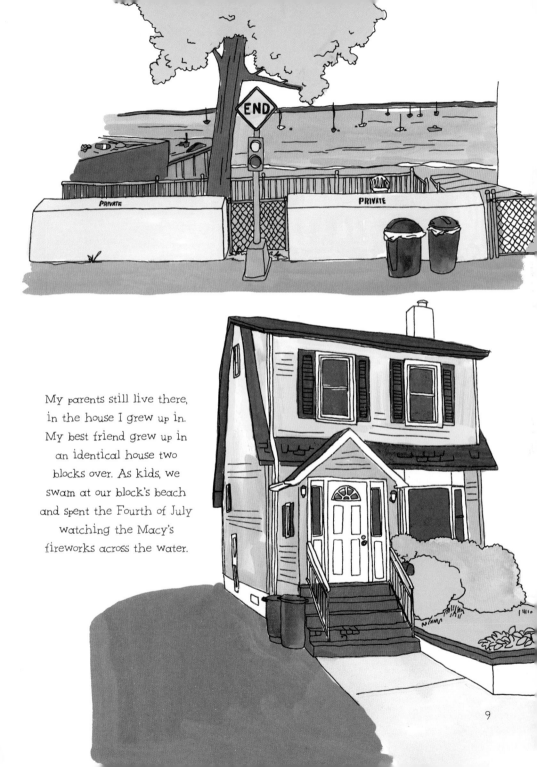

My parents still live there,
in the house I grew up in.
My best friend grew up in
an identical house two
blocks over. As kids, we
swam at our block's beach
and spent the Fourth of July
watching the Macy's
fireworks across the water.

9

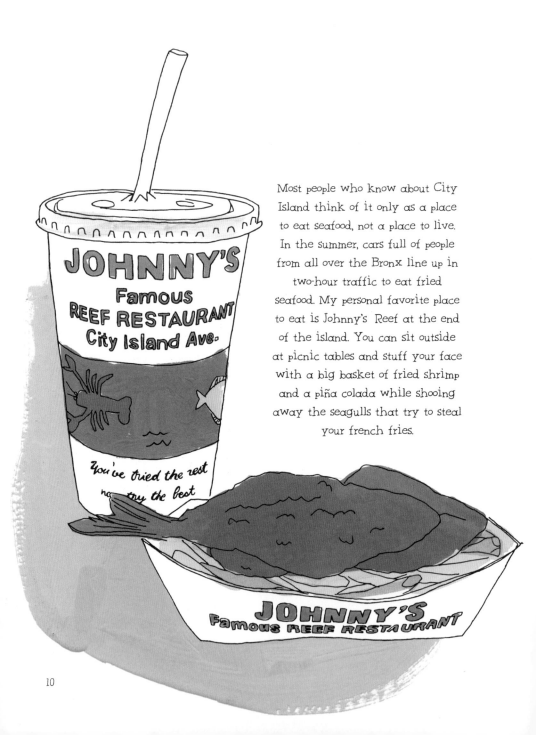

Most people who know about City Island think of it only as a place to eat seafood, not a place to live. In the summer, cars full of people from all over the Bronx line up in two-hour traffic to eat fried seafood. My personal favorite place to eat is Johnny's Reef at the end of the island. You can sit outside at picnic tables and stuff your face with a big basket of fried shrimp and a piña colada while shooing away the seagulls that try to steal your french fries.

If you were born on City Island, you're called a clam digger (that's me). If you moved there, you're a mussel sucker (my parents).

The population is about forty-five hundred people, and it feels like everyone knows everyone else, and families stay around for generations.

It takes about forty-five minutes to get to City Island from midtown Manhattan by train. It's the final stop on the 6 train, followed by a ten-minute bus ride.

City Island has some fame—the 2009 indie movie *City Island* featured Andy Garcia as the father of a dysfunctional family. My mom, and probably most residents of City Island, bought the DVD.

JACK ROTHMAN

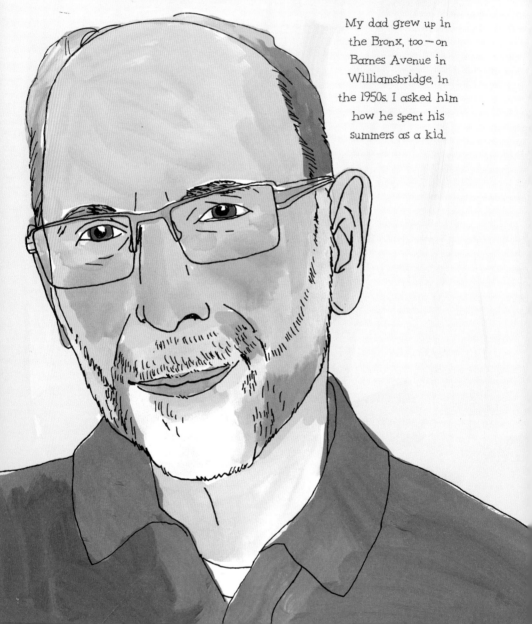

My dad grew up in the Bronx, too — on Barnes Avenue in Williamsbridge, in the 1950s. I asked him how he spent his summers as a kid.

"On the weekends, you just stayed out on the street. You ate breakfast, and then you went out and didn't come home until you were hungry. If you could, you'd find food on the street, or at your friends' parents' house; then you would just go home at dinner time. Some of the games we played were stickball, Triange, and Slugs. For stickball, we would climb up the fire escape and steal someone's mop and then unscrew the mop part to get the stick. And then everyone used to search in their house for a Spauldeen ball.

If you didn't have a Spauldeen ball, you'd go fishing in the sewers for them. You'd get a long pole or stick and put chewed bubble gum on the end and push it onto the ball.

13

But sometimes they were brittle; they'd been down there so long, they would be all dried up and they'd just crack. We used cars as our bases, and you'd pitch from the sewer cap. The losers of a stickball game would have to line up for Asses Up. That meant they had to line up against a wall with their butts in the air, and the winners got to fire the Spauldeen as fast and hard as they could at your ass.

Triangle was a game where you pitched the ball with your thumb on a bounce and then slapped it with an open hand. Slug was like handball, but you had to bounce it before hitting the wall. Then there was Johnny on a Pony. Everyone made a pyramid

We played against the outside apartment wall on Barnes Ave, and it drove the woman who lived there crazy. She used to open her window and throw a pot of boiling water at us.

like cheerleaders on our hands and knees up against a wall. And the last person would run and jump and try to make it to the top, and would crash everyone down. There was no supervision, so we did stuff like that. Our parents just let us out on the street all day; it was different in those days. If they wanted you for lunch or something they used to yell your name out the window.

My dad (middle) and two friends, 1963

Then when we were older, like fourteen, a bunch of us would just ride the subway all day. We used to ride between the cars and some of the guys would try to jump off the train while it was moving. There were no air conditioners, so a lot of people would ride in between to keep cool. We didn't care where we went. That was the best part, getting on and off the train all over the city."

My dad's dad, my grandfather, grew up on the Lower East Side in a tenement building after his parents emigrated from Poland. When I'm walking along Houston Street I often wonder if he ate at some of the places that still exist, the ones that stuck around even after most of the Jewish immigrant residents moved away.

Katz's Deli

You can get a really thick hand-carved pastrami sandwich here, and every table gets a silver bowl of pickles. They still use the old ticket method — you get a ticket upon entering, everything you order goes on the ticket, and you can't leave without handing back your ticket and paying.

RUSS & DAUGHTERS
APPETIZERS

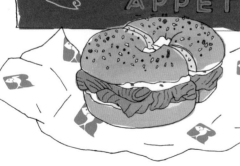

Russ & Daughters

This is the place to get a classic lox on bagel sandwich. They specialize in smoked fish of all kinds.

YONAH SHIMMEL.. ...KNISH BAKERY

Original
SINCE 1910

Yonah Shimmel Knish Bakery

There are so many knishes to try here that when I went with a friend we way over-ordered and stuffed our faces. I was happy to see noodle pudding on the menu.

The Origin
YONAH SCHIM

KNISHE

OPEN

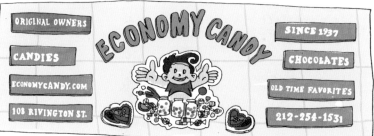

ORIGINAL OWNERS

ECONOMY CANDY

SINCE 1937

CANDIES

CHOCOLATES

ECONOMYCANDY.COM

OLD TIME FAVORITES

108 RIVINGTON ST.

212-254-1531

Economy Candy

They sell candy you thought was discontinued and candy from around the world. You can buy candy in bulk by scooping it into a scale and weighing it. The candy wrapper designs are intriguing and I always leave the store with the candy with the weirdest graphics even if it has a coconut flavor.

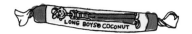

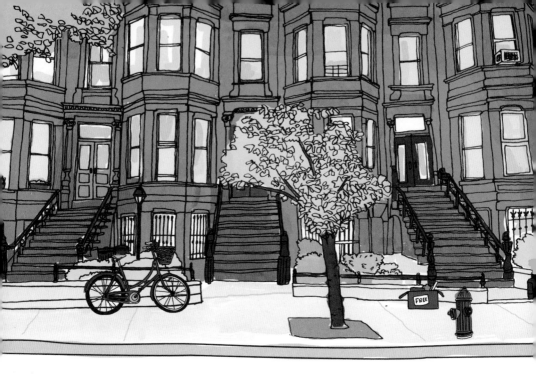

Two generations later, I am still in New York.

I live in Park Slope, Brooklyn with my husband, Matt, and our dog. I like this neighborhood because it's full of classic, beautiful brownstones. Residents leave books they've read on their stoop to share, an endless neighborhood library. The block organizes summer parties at which kids get their faces painted with whiskers. Someone opens the fire hydrants, and water sprays into the street.

We get everything delivered:

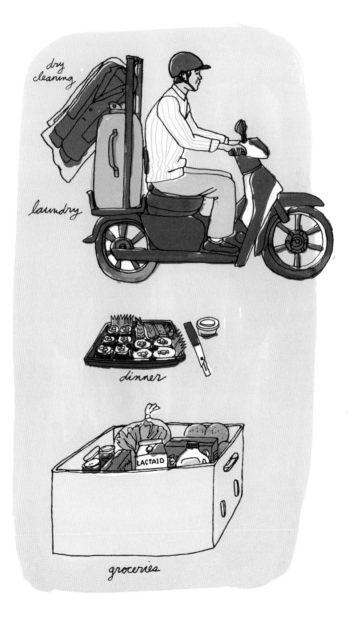

Matt's family lives in Iowa and always asks us a lot of questions about what it's like to live in New York:

ISN'T IT DANGEROUS?

No, not anymore.

YOUR RENT IS HOW MUCH?

$2,050 a month

YOU DON'T HAVE A CAR?

We take the subway.

DOES EVERYONE WEAR BLACK AND WALK DOWN THE STREETS TALKING ON THEIR CELL PHONE?

FUHGEDDA-BOUDIT!

Kind of, yes.

A older woman from his hometown visited New York once in the '80s and said she would never return. She recently told us the reason why:

"I was walking with another couple around midtown, but we needed a break—we were tired and wanted to sit down. I couldn't understand why there was nowhere to sit down in New York, no benches. Finally we decided to go into Grand Central Terminal, and we found the only open bench. I sat down next to a construction worker who held his hard hat on his lap. Then he turned to me and smiled, and I smiled back, and he lifted his hard hat to um... you know... showed me his... he exposed himself."

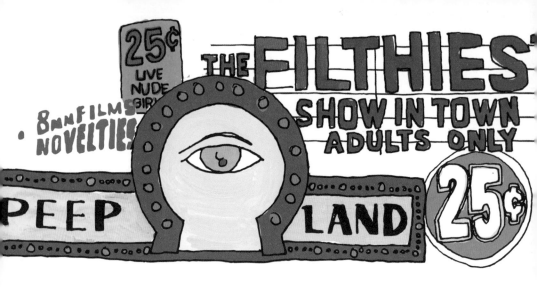

New York has changed a lot since the '80s.

When I was growing up, Times Square was full of peep shows, and there were tons of homeless people. It was where you'd go to buy a fake ID. I remember my dad using "the Club" to protect our car from getting stolen and taking the face off the car radio so that nobody would break in to steal it. One time, our car was broken into because we accidentally left a roll of quarters visible. I also remember the subway trains were full of graffiti. There was graffiti everywhere.

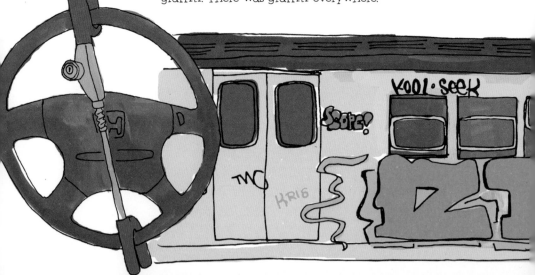

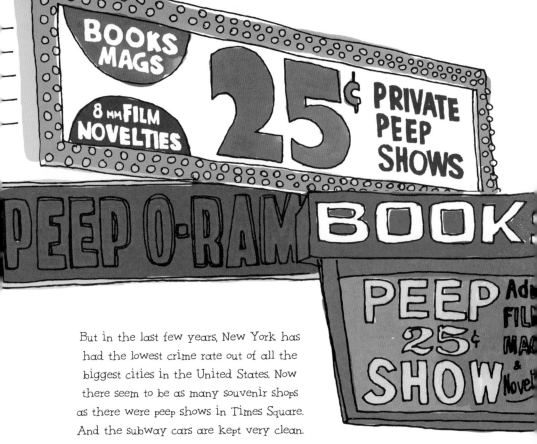

But in the last few years, New York has had the lowest crime rate out of all the biggest cities in the United States. Now there seem to be as many souvenir shops as there were peep shows in Times Square. And the subway cars are kept very clean.

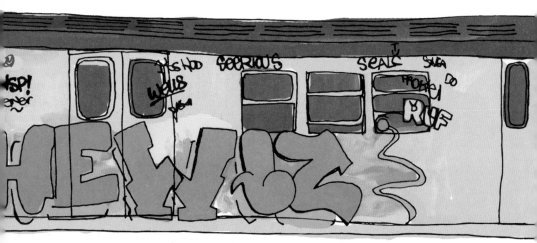

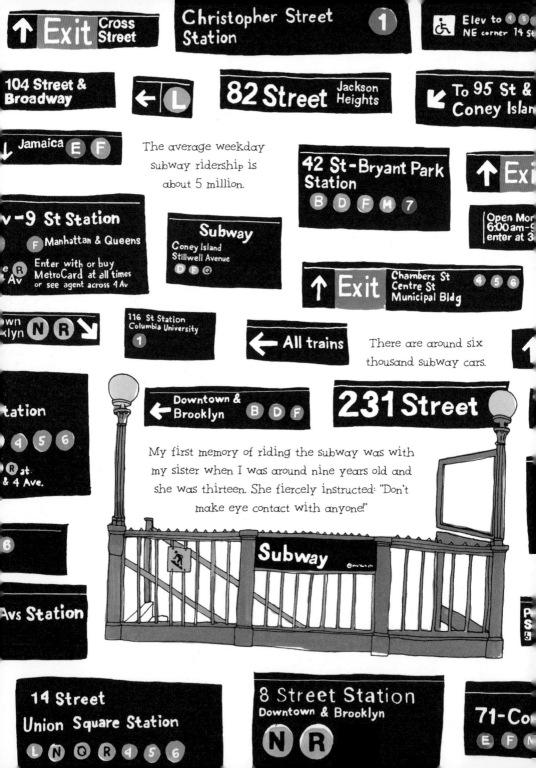

↑ Exit Cross Street

Christopher Street Station ①

Elev to ④⑤... NE corner 14 St

104 Street & Broadway

← Ⓛ

82 Street Jackson Heights

↙ To 95 St & Coney Islan...

↓ Jamaica Ⓔ Ⓕ

The average weekday subway ridership is about 5 million.

42 St-Bryant Park Station
Ⓑ Ⓓ Ⓕ Ⓜ ⑦

↑ Exi...

...v-9 St Station
Ⓕ Manhattan & Queens
...e Ⓡ Enter with or buy MetroCard at all times or see agent across 4 Av

Subway
Coney Island
Stillwell Avenue
Ⓓ Ⓕ Ⓠ

Open Mor... 6:00 am-9... enter at 3...

↑ Exit Chambers St Centre St Municipal Bldg ④ ⑤ ⑥

...wn ...kly Ⓝ Ⓡ ↘

116 St Station Columbia University ①

← All trains

There are around six thousand subway cars.

...tation ④ ⑤ ⑥ Ⓡ at & 4 Ave.

← Downtown & Brooklyn Ⓑ Ⓓ Ⓕ

231 Street

⑥

My first memory of riding the subway was with my sister when I was around nine years old and she was thirteen. She fiercely instructed: "Don't make eye contact with anyone!"

Subway

...vs Station

P.S. 5...

14 Street Union Square Station
Ⓛ Ⓝ Ⓠ Ⓡ ④ ⑤ ⑥

8 Street Station Downtown & Brooklyn
Ⓝ Ⓡ

71-Co...
Ⓔ Ⓕ Ⓜ...

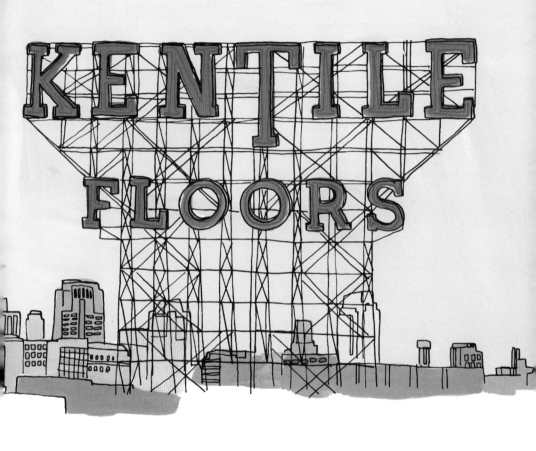

The highest station is Smith and W. 9th Streets in
Brooklyn (F and G trains), which is eighty-eight feet above
street level. Riding from this station, you get a great view
of Brooklyn and of the beautiful old Kentile Floors sign.

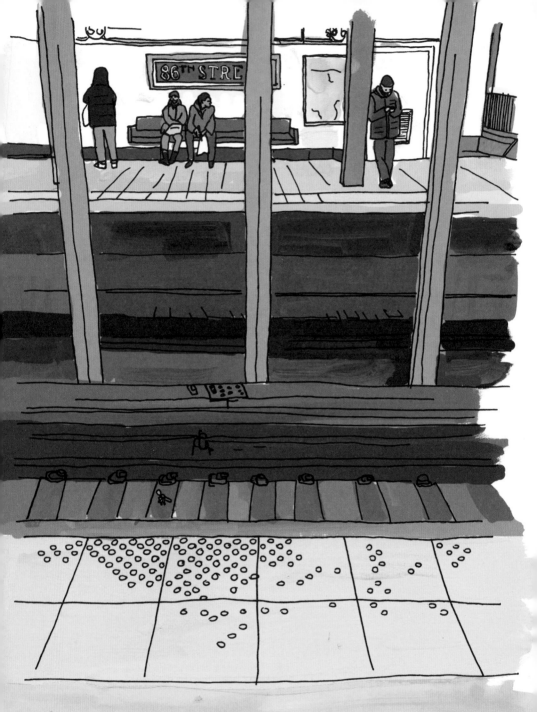

One late night a few years ago, I was standing with my friend on the subway platform. We were joking around, and somehow my keys flew out of my pocket and onto the tracks.

We stood there astonished. I couldn't get into my apartment that night without them. But there was no way I was going to jump down onto the tracks. We stared down arguing about how likely it was that a G train would come (it was 2 a.m.) when a young man jumped down on the tracks, picked up the keys, jumped back up on the platform, and handed them to me. I was so shocked I could hardly thank him before he nodded and walked away. Twenty minutes later, when the train finally did come, I saw him asleep on the other side of the car. I wrote him a note with my name and phone number thanking him again, and offering to treat him to a meal. I slipped it into his pocket, but I never heard from him.

I asked a subway clerk about losing things on the tracks. He told me he gets called down three to four times a day to rescue a cell phone. The weirdest thing he was asked to recover was

a pair of dentures.

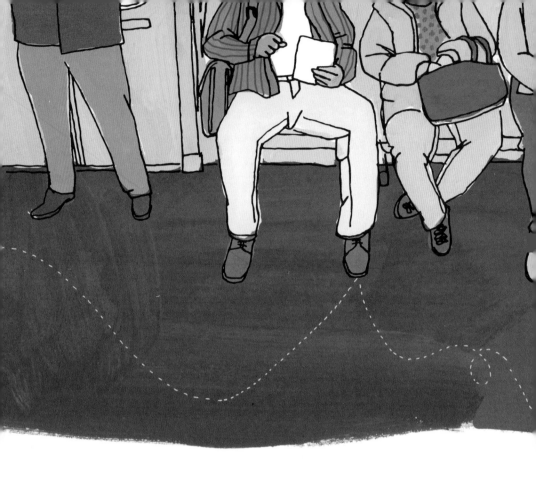

Riding the subway, I am always distracted by the
random interactions among strangers who happen to
sit next to each other. I find it hard not to listen to
other passengers' conversations or watch them as
they nod off while sleeping across from me.

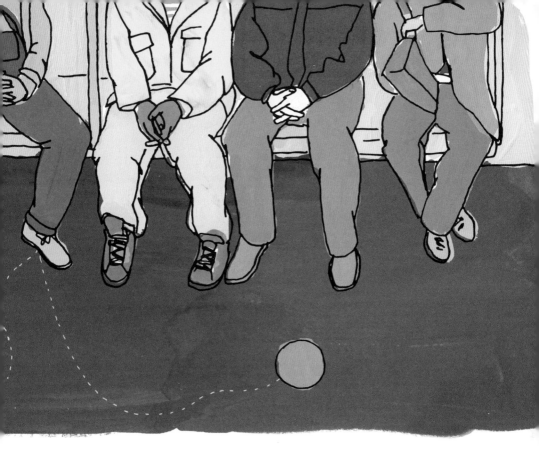

One time I was on the subway when an unclaimed
ball started rolling around. Someone started an
impromptu sitting-kicking game, passing the ball
around passenger to passenger, rolling it across and
down the subway car.

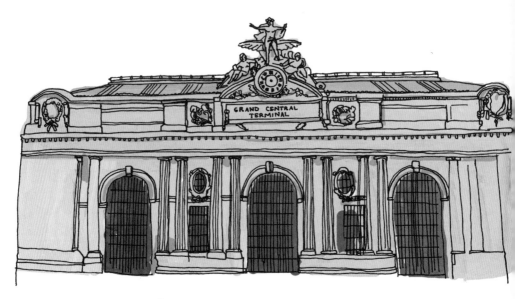

Grand Central Station

Grand Central Station is the largest train station in the world, with forty-four platforms and sixty-seven tracks. The clock on the exterior is the world's largest piece of Tiffany glass.

The ceiling in the Main Concourse is a gorgeous depiction of the astronomical constellations designed by French artist Paul Cesar Helleu. For twelve years, it was being restored from what they thought was coal- and diesel-smoke damage, but when they tested it, it turned out to be actually tar and nicotine build-up from so many smokers. After all that cleaning, the bright turquoise color finally revealed itself again in 1998. They left a tiny patch untouched above Michael Jordan's steak house to show how much grime had been on there before the cleaning.

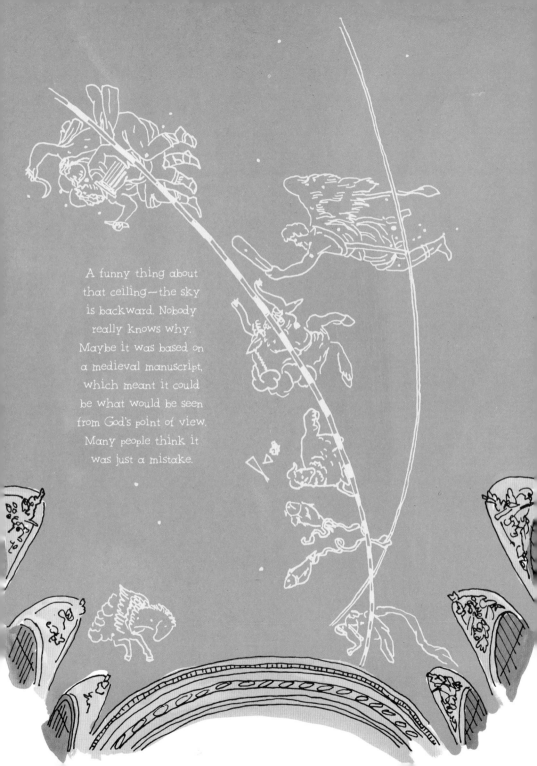

A funny thing about
that ceiling—the sky
is backward. Nobody
really knows why.
Maybe it was based on
a medieval manuscript,
which meant it could
be what would be seen
from God's point of view.
Many people think it
was just a mistake.

Downstairs in the dining concourse there is a "whispering gallery" in front of the Oyster Bar. If you stand on one side of the ceramic arches and whisper into them, someone on the other side can hear what you are saying. Something about the acoustics of the curves of the arches carries the sounds, making it a popular place for couples to propose marriage or lovers to whisper dirty thoughts.

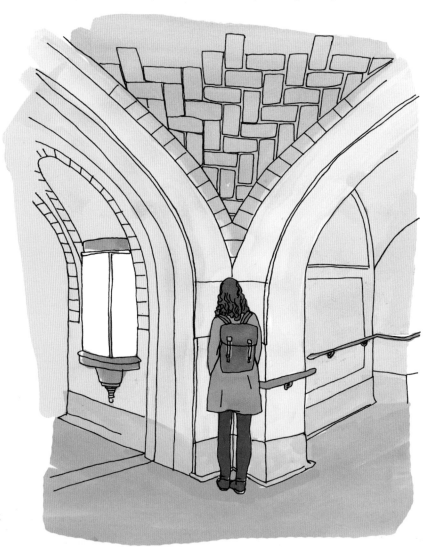

My favorite spot in Grand Central is the hidden bar Campbell Apartment. It's unlikely that you would stumble across this place; you have to walk to the back of Cipriani's on the balcony of the main concourse to get to it. What used to be the office of financier John W. Campbell is now a fancy cocktail lounge. There are a beautiful restored 1920s details, a hand-painted ceiling, and an enormous fireplace. The cocktails are also rather delicious, especially the Prohibition Punch.

I had heard that Grand Central has a secret tennis court and was determined to find it. A friend and I took stairway after stairway up and around and finally stumbled upon it, on the fourth floor. It's called the Vanderbilt Tennis Club, and it's open to the public. The two courts are small, but they feature Grand Central's iconic arch windows that overlook Park Avenue. If you are a tennis-playing, traveling businessman, this might be a good place to waste time while you wait for your train.

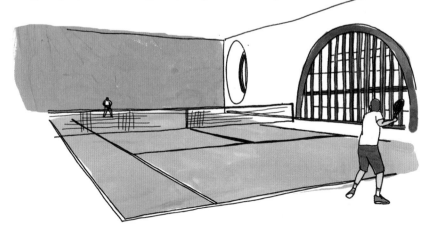

The New York Public Library

A few blocks away is the New York Public Library, which made a grand appearance in the 1984 movie *Ghostbusters*. In the 1930s, Mayor Fiorello LaGuardia named the iconic marble lion sculptures that guard the entrance: Patience, on the south side, and Fortitude, on the north.

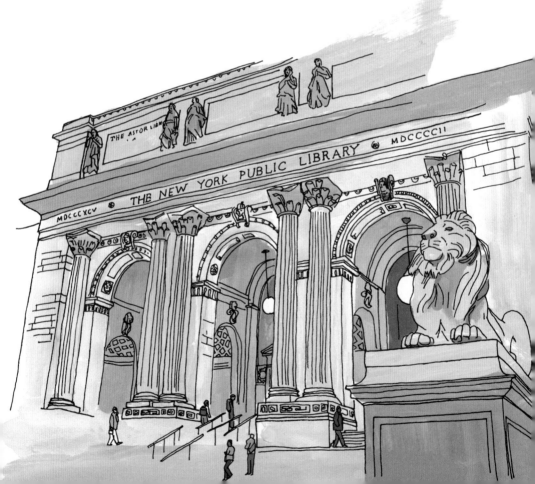

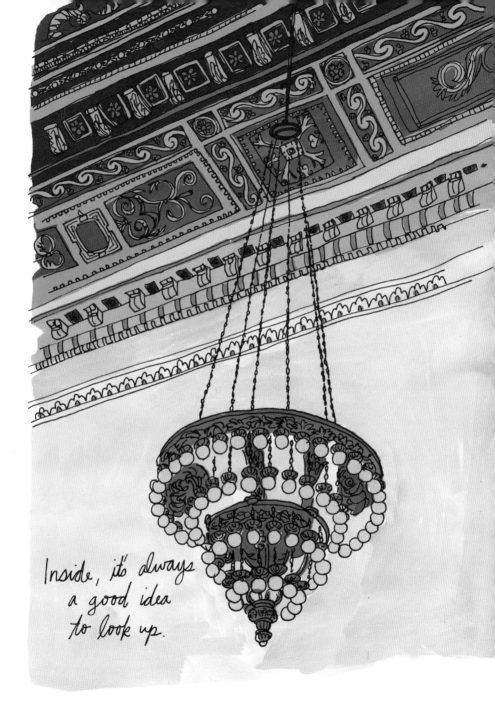

Inside, it's always a good idea to look up.

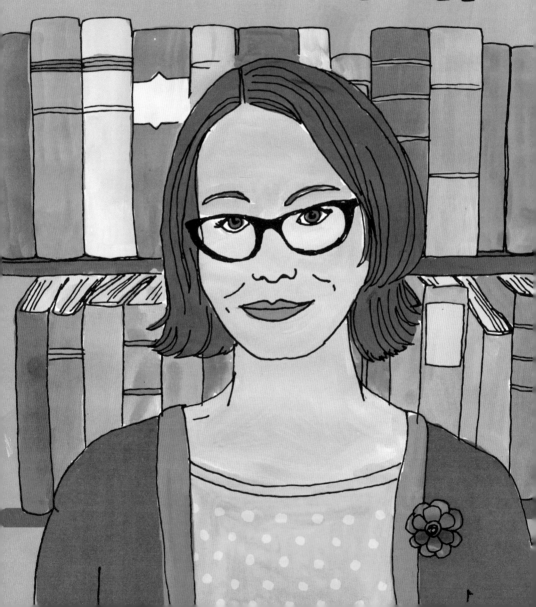

I asked a librarian about her job:

JESSICA PIGZA

"I work in the Rare Book Division at the New York Public Library's historic flagship building. I've been here since 2007, but I am still in awe of the place and its collections. I also still find it strange that I come to work every day at what is an international tourist attraction. It's sometimes so crowded that it can feel more like Grand Central than a research library. But the visitors who fill the halls are curiosity seekers from all over, and a library's an ideal spot for the curious. And once you've taken a seat in one of the reading rooms, there's also an element of peace amid the bustling scene.

My workdays vary quite a bit depending on what's going on, but the big goal behind everything I do is to connect people with our collections. In practice, this might mean teaching

I'm fascinated by the parts of the building that reflect the library's long history — a carpentry shop, a book bindery, a caretaker's apartment, a pneumatic tube system that remains behind the scenes.

classes, talking with visitor groups, or working with individual readers. My most memorable readers are the ones who have found their way here not through traditional academic channels but as a means of meeting some other need. Like the bartender who consulted historic cookery books as part of a project to bring old-fashioned cordials or shrubs back into vogue. Or the novelist who needed to sit for a bit with a certain edition of a text in order to describe realistically his characters' actions. I love the books at the New York Public Library as much as I love the readers who use them. All books tell stories, and books that have survived hundreds of years ago tell more stories than you might imagine. By looking closely at the watermark on the paper a book is printed on, at handwritten notes a long-ago reader left behind on a page, or at how a book is bound, you can coax a book to reveal its stories."

My favorite books are the ones that bare their handmade natures. I never get tired of looking at tiny English books of hours bound in elaborately embroidered cloth, or at hand-colored illustrations.

SOME LESSER-RECOGNIZED, UNDER-APPRECIATED BUILDINGS OF MANHATTAN

The American Standard Building
40 WEST 40TH ST

The Potter Building
38 PARK ROW

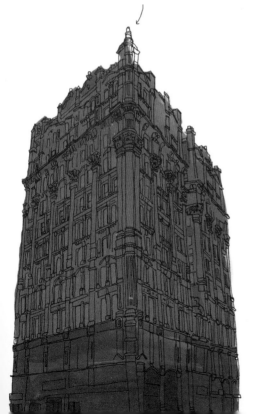
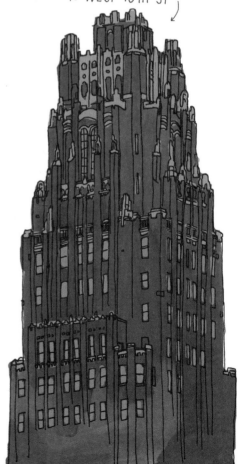

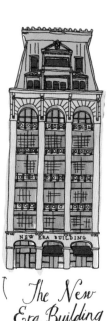

The New Era Building
495 BROADWAY

The Dorilton 171 WEST 71 ST

The Puck Building
295 LAFAYETTE ST

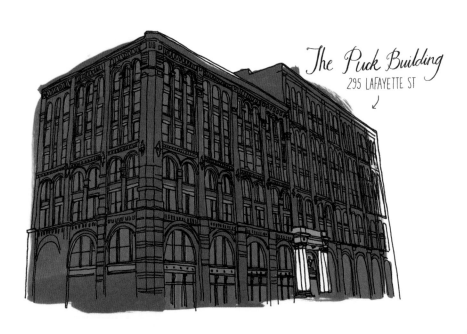

40

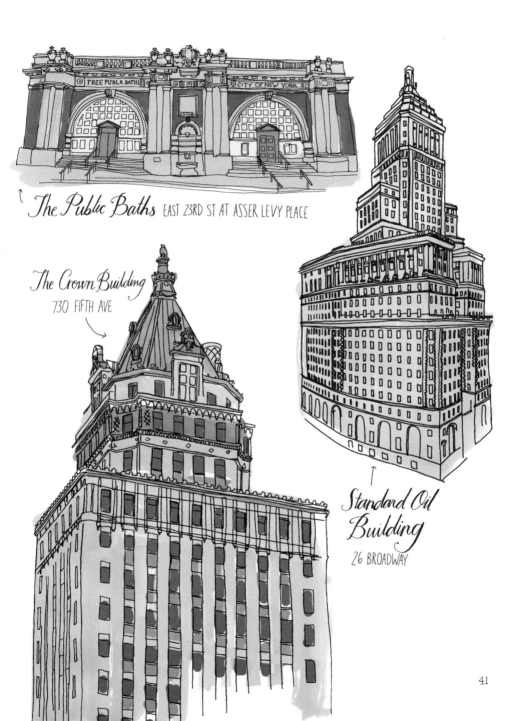

The Public Baths EAST 23RD ST AT ASSER LEVY PLACE

The Crown Building
730 FIFTH AVE

Standard Oil Building 26 BROADWAY

41

Public Art:

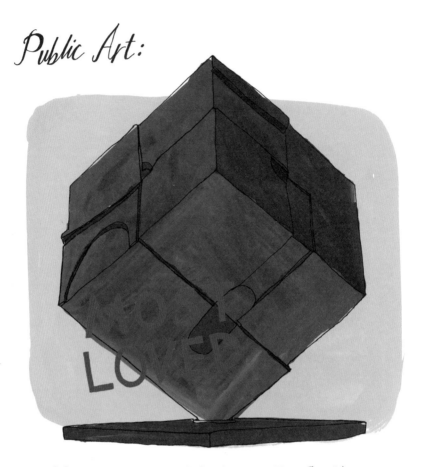

What I have always called "The Astor Place Cube," is
actually titled "Alamo," by Tony Rosenthal, and was
installed in 1967. My friends and I often used the fifteen
foot steel cube as a meeting place in the East Village. It's
always been one of my favorite pieces of public art
because even though it seems so simple, it invites
interaction by spinning if you push it hard enough. It's
been decorated like a Rubik's cube, and covered in
camouflage knit by the artist Olek.

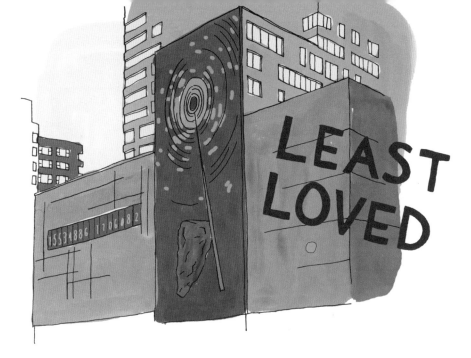

LEAST LOVED

The rumor that I had heard about the flipping numbers on the side of One Union Square South was that it is the National Deficit. I couldn't believe how fast it was gaining. That turned out to be very incorrect. It's actually part of an art installation called "Metronome," created by Kristin Jones and Andrew Ginzel. The fifteen LED numbers are a section of the artwork called "The Passage" that displays the time in twenty-four hours by hours, minutes, seconds, tenths of seconds, and then how much time is remaining in the day, broken up the same way. The other sections of the artwork include a huge piece of rock and a long bronze cone pointer sitting over concentric circles that end in a void where steam puffs out during certain times of the day.

As strange and striking as it is, I've always thought this was such an ugly piece of artwork. Apparently I'm not alone. A July 2005 piece in *The New Yorker* stated that co-creator Kristin Jones thinks it is "the most unloved piece of public art in the city."

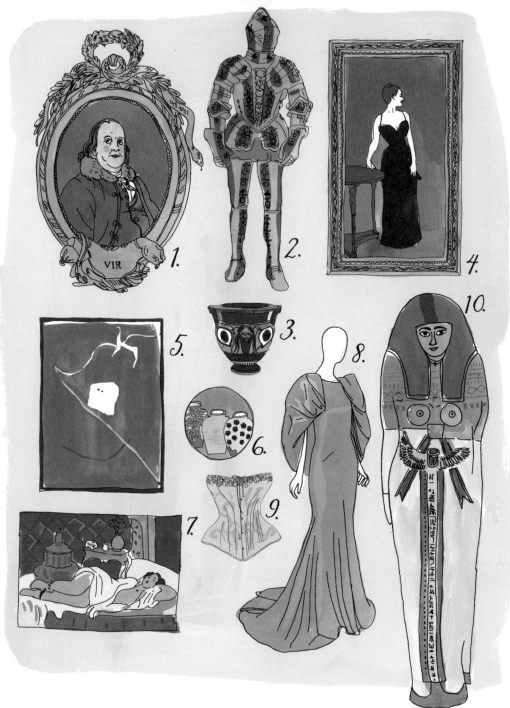

1.

2.

3.

4.

5.

6.

7.

8.

9.

10.

VIR

TEN TREASURES I WOULD TAKE HOME FROM THE METROPOLITAN MUSEUM OF ART:

1. *Benjamin Franklin* (1706-1709) *by Joseph Siffred Duplessis* —to hang over my couch.

2. *Armor Garniture of George Clifford, Third Earl of Cumberland* — I'd have him stand in my entryway to greet my guests.

3. *Terracotta column-krater* — for my side table.

4. *Madame X by John Singer Sargent* —I might have someone restore it to Sargent's original intention, with the strap of the dress hanging off her right shoulder, before I hang it in my bedroom.

5. *Circus Horse by Joan Miró* — for my office.

6. *Dish with Design of Three Jars* — to use as a fruit bowl in my kitchen.

7. *Odalisque Harmony in Red by Henri Matisse* — to hang in my pink bathroom.

8. *Evening Dress by Gianni Versace* — to wear at our New Year's party.

9. *Corset Maison Léoty* — to wear on a special evening.

10. *Cartonnage* (c.a. 945-712 BC) *of a Woman* — just because it's so awesome.

The Natural History Museum

Even though it was an annual elementary school trip, I've never gotten tired of visiting the dinosaur skeletons or walking through the gems-and-minerals exhibit. My mom can't walk through the room of dioramas without breaking out in goose bumps.

The Museum of Modern Art (MoMA)

Matisse's "The Red Studio," Van Gogh's "Starry Night," Picasso's "Les Demoiselles D' Avignon"... visiting MoMA always makes me feel like I've walked into my old art-history textbook.

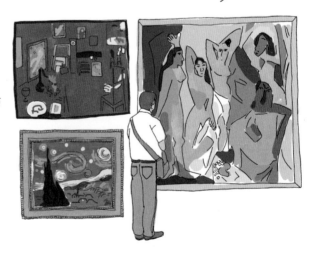

The Guggenheim

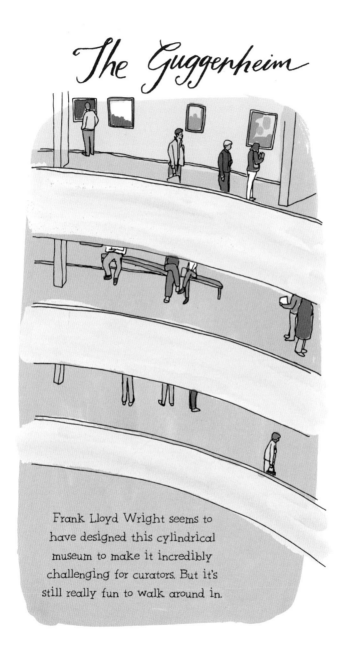

Frank Lloyd Wright seems to
have designed this cylindrical
museum to make it incredibly
challenging for curators. But it's
still really fun to walk around in.

FELTLY
HATS

CHOCK

Lower East Side Tenement Museum

You can see re-enactments of
immigrants living in tenements
and visit restored apartments.

Intrepid Sea, Air & Space Museum

This museum is on the old aircraft carrier used in WW II.

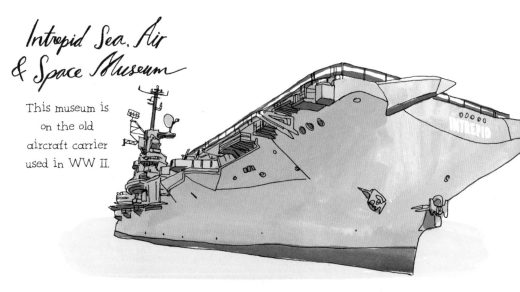

The Queens Museum of Art

You can see an incredible architectural model of the whole of New York City. "The Panorama," created by Robert Moses for the 1964 World's Fair, continues to get updated and features more than 800,000 individual structures representing every building in New York.

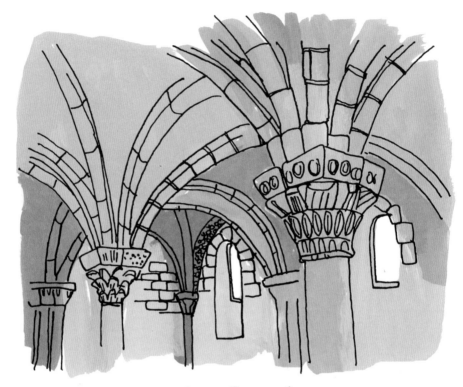

The Cloisters

This museum, assembled from parts of European
buildings from the twelfth through the fifteenth
centuries, is the home of the famous Flemish unicorn
tapestries and tons of other incredible medieval
artifacts. You can walk through the corridors
pretending you are a character in *Game of Thrones*.

Museum of the Moving Image

An homage to movies and television and video games, this museum has an enormous collection of licensed merchandise, from games and toys to figurines, sheet music, and comic books (for a total of 20,982 artifacts of this kind). You can visit that Fred Flintstone mug you used to have as a kid.

New York Transit Museum

This museum is located inside the unused Court Street subway station in Brooklyn. You can walk through historic subway cars and check out signage and memorabilia from all kinds of New York transportation.

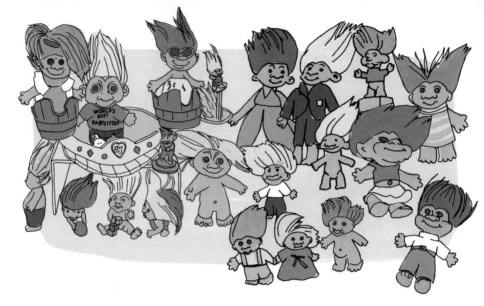

The Lower East Side Troll Museum

I recently found out about the New York Troll Museum, and a friend and I made an appointment for a visit. Turns out the museum is actually the first room in Reverend Jen's (Miller) sixth-floor walk-up apartment. While there is no museum fee, there is a sign taped to a piggy bank that says "Suggested donation ." Rev. Jen transformed the room into a shrine for troll dolls, with brightly colored swirls painted on walls that are covered by shelves of trolls and artwork about trolls. Wearing a pair of elf ears, Rev. Jen and her Chihuahua, Rev. Jen Junior, gave us a guided tour of the small room and her collection. We learned how to distinguish the original Dam trolls and Norfin Trolls from Russ trolls, Ace Treasure Trolls, and black market trolls by their marks, how pointy their ears are, and their body shapes.

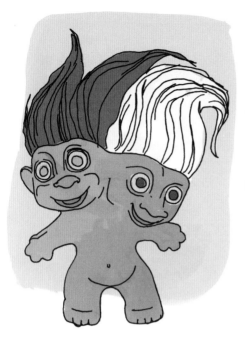

She told us stories
about acquiring
her trolls, and we
admired the
rarest troll, which
she calls the
Mona Lisa of her
collection: a 1960s
two-headed troll.

In 2010, there was a steam-pipe explosion in the museum, and all the trolls and troll paraphernalia got wet. Rev. Jen told us she spent many hours brushing and cleaning each troll's head of hair. Because of the disaster, many of her psychedelic troll paintings on canvas are still warped and they twist away from the wall, making the space feel even more like a troll funhouse.

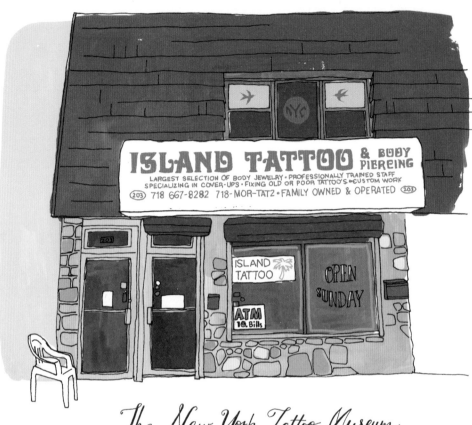

The New York Tattoo Museum

After reading about the New York Tattoo Museum on Staten Island, I convinced a group of friends to take a Staten Island car trip adventure. Covered in tattoos and wearing Superman pants, Dozer took us to the second floor of his shop, Island Tattoo, to his museum. The museum comprises three tableaux with mannequins showing the history of tattoos: tribal methods, ancient Japanese techniques, and World War II-era tattooing. Behind glass there was an extensive collection of tattoo machines. Dozer also pulled out pages of tattoo flash, including one from the notorious tattoo artist Sailor Jerry. He showed us a tattoo of a rooster and a pig and explained the folklore behind getting one animal tattooed on each of your feet.

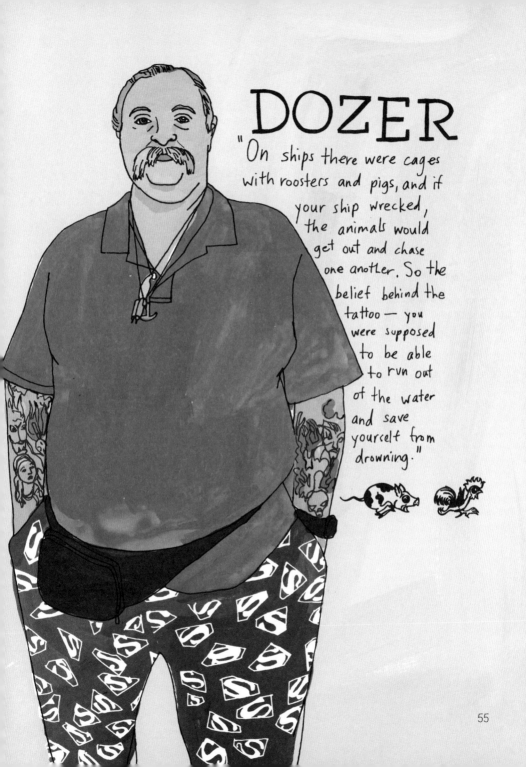

DOZER

"On ships there were cages with roosters and pigs, and if your ship wrecked, the animals would get out and chase one another. So the belief behind the tattoo — you were supposed to be able to run out of the water and save yourself from drowning."

Across the room there was a display of hundreds of photographs
of men with the same tattoo. I asked Dozer about it:

"We all know about 9-11. After the towers went down, there were 343 firemen who perished, along with thousands of other people. A lieutenant firefighter, Gary Lustig, had drawn up a tattoo for the rest of the firemen who survived in his firehouse. He decided he wanted to take it further. He said let's take it to a tattoo shop and let's see if we can use it for all the FDNY firehouses, and let's see what we can do to raise money. He brought the idea to us, and we cleaned up his drawing so it was tattooable. A tattoo this size with the amount of detail would be around $200, but they wanted to use this as a fundraiser so we decided to make it $100 with half going to charity. We told customers to pay us $50 in cash, and to also bring a check made out to the UFA for the widows and children's fund for the other $50. That way people would know that we were really straight and the money would go directly to them. When they got

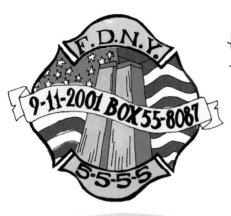

the tattoo, we had them take a picture in front of the flag and they would write their name and engine company down. We hung them up around the entire parlour. And we got some press about it, so people came to look at the pictures.

We didn't know the names of the 343 firefighters who died yet at this time, so as people came in, a firemen would say, 'Oh, I remember going through school with him: I'm so glad he wasn't one of them.' It still gives me chills.

Here's what the patch meant: 55-8087, that was the number of the firebox that was pulled closest to the towers. The four fives symbolizes when a fireman is down in a building, the firehouse rings their bell in four intervals of five rings. Just giving charity $50 a tattoo, we raised over $17,500 for the widows and children."

It's a bond of a group of individuals who got a tattoo to remember the worst catastrophe to ever hit American soil.

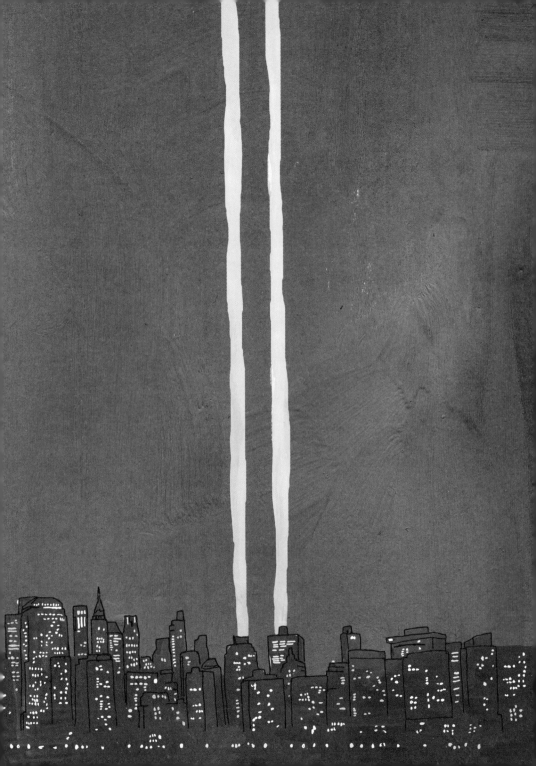

STATEN ISLAND

While on Staten Island, we decided to see what other treasures the "forgotten borough" (that's what Dozer called it) held. We visited Fort Wadsworth and got a great view of the Verrazano-Narrows bridge,

and then the Frank Lloyd Wright house, though we were scared to get too close because we saw people inside.

We made a quick stop at The Jacques Marchais Museum of Tibetan Art to check out the sculptures and objects. The museum, perched on Lighthouse Hill, is designed to resemble a small Himalayan mountain monastery.

Tugboat Graveyard

We pulled off the side of the road and hurried past
a few "No Trespassing" signs to check out a
mysterious tugboat graveyard. There are chunks of
decomposing tugboats, barges, and old ferries. It feels
very eerie, like a place a bunch of kids might come
across in a horror movie. Looking around at all the
boats, you can't help but imagine what they once
looked like when they were whole and new. I got
chills thinking about how much the collapsing
structures feel like leftover skeletons, slowly sinking.

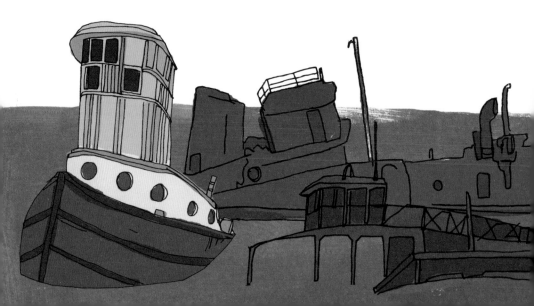

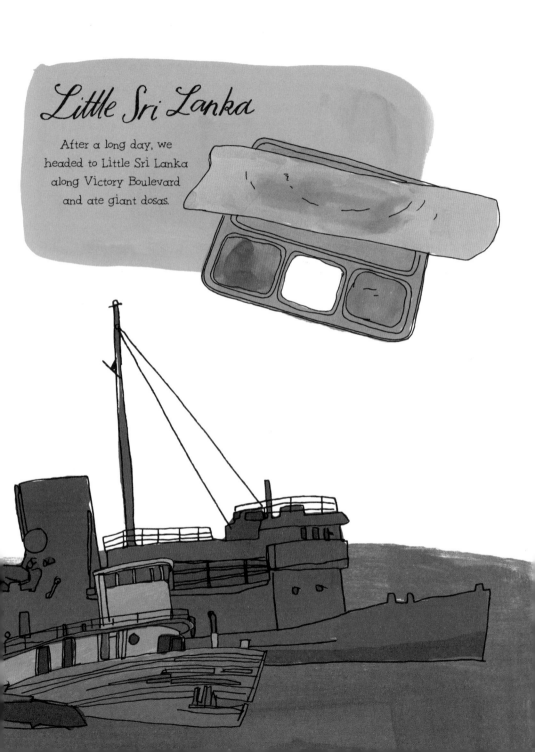

Little Sri Lanka

After a long day, we headed to Little Sri Lanka along Victory Boulevard and ate giant dosas.

Queens

Queens is the most ethnically diverse urban area in the world. You can find people from 100 nations speaking more than 138 languages.

HOLA مرحبا 你好 Olá

 Welcome ਹੈਲੋ नमस्ते 안녕하세요

سلام CZEŚĆ Yειá σou CIAO

привіт BONJOUR привет KUMUSTA

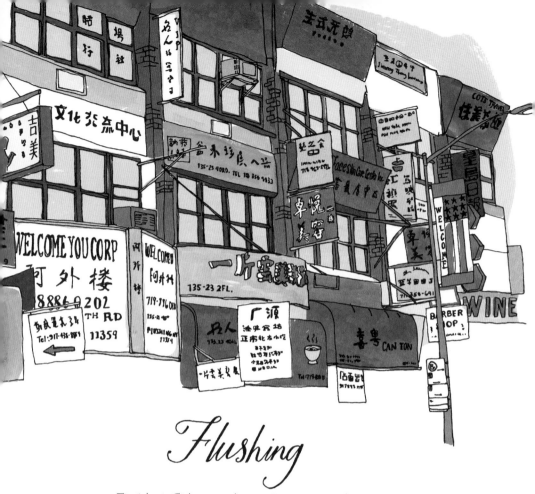

Flushing

Flushing's Chinatown is an adventurous eating
destination. In the Flushing Mall grocery store you
can find tons of unfamiliar fruits and vegetables.
Turtles and eels are piled in buckets on the
ground at the fish counter. Across the street, at
the Golden Shopping Mall, we watched as a man
hand-pulled noodles. At this underground food
court, you can order traditional dishes like
fish-meatball noodle soup, sesame shaobing, and
smoked pig's intestines.

Spa Castle

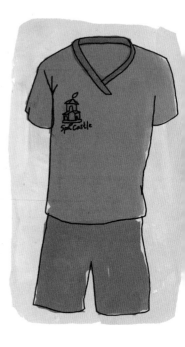

Close by in College Point is Spa Castle, a five-story Korean bathhouse. Upon entering you get a uniform. Women must wear the orange shirt and pink shorts; men wear white shirts and blue shorts. Everyone gets a watch that opens your locker and that you wave across machines to pay for food or massages. In the facility's sauna valley, you can sit in a variety of types of saunas: far-infrared, (LED) sauna, or jade sauna, which, according to the sign, "strengthens bladder and eyes," among other things.

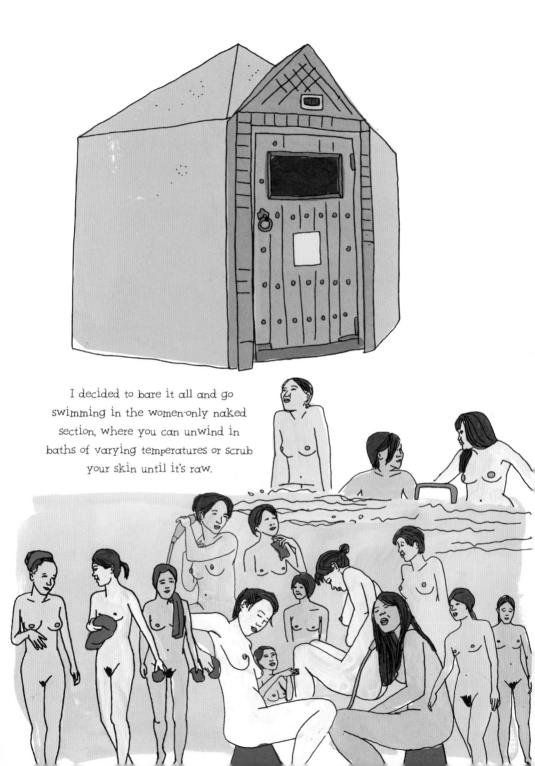

I decided to bare it all and go
swimming in the women-only naked
section, where you can unwind in
baths of varying temperatures or scrub
your skin until it's raw.

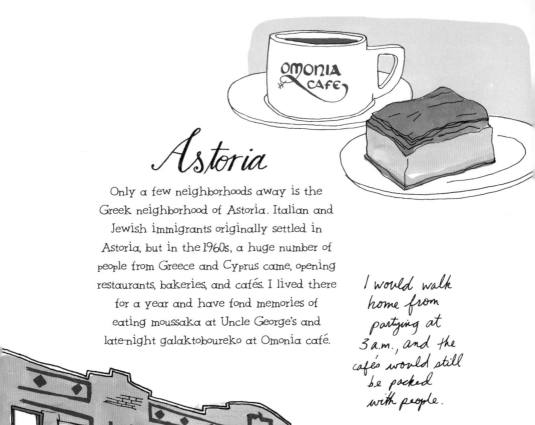

Astoria

Only a few neighborhoods away is the Greek neighborhood of Astoria. Italian and Jewish immigrants originally settled in Astoria, but in the 1960s, a huge number of people from Greece and Cyprus came, opening restaurants, bakeries, and cafés. I lived there for a year and have fond memories of eating moussaka at Uncle George's and late-night galaktoboureko at Omonia café.

I would walk home from partying at 3 a.m., and the cafés would still be packed with people.

Beginning in the 1970s, Astoria's Arab population grew as well. Now on Steinway Street between 28th Avenue and Astoria Boulevard, you can find a variety of hookah bars to relax in.

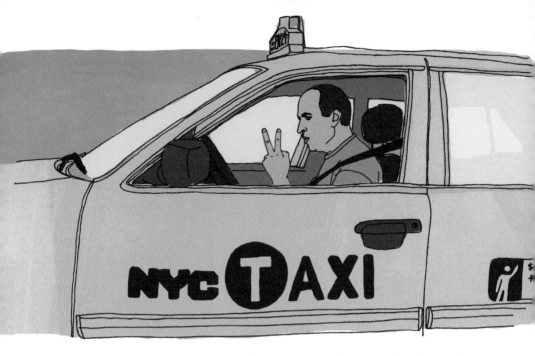

I took a cab home late one night with a driver who lives in Astoria, and he told me about what it was like being a taxi driver.

"I am from Egypt. It's not safe now since the revolution. I want to bring my family here, so I got this job. I enjoy driving, but not as much in a cab. Driving in a cab is long hours — twelve hours a day in bad traffic. I used to be an accountant, but I hated it. I hate numbers. I fell asleep at my job. I was bad at it because I have a very bad memory. To get the hack license for the cab, I had to go to school, and then you have to pass a hard exam about geography, hotels, expressways, street names, and how to avoid traffic. When I started, I used my GPS, it makes it easier for me. I work 5 p.m. to 5 a.m. If I have to go to

the bathroom, I go to Starbucks or McDonald's. If I get hungry, I pretty much go to same place. Some days you drive all twelve hours; other days you finish at midnight and just go home. Forty-first and Ninth has dollar pizza, so good. Crazy! So fresh. Right from the oven. Get two slices and one coke, when you drive.

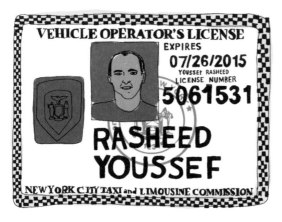

Sometimes you have to choose the customer, but I hate to do that. It's not fair.

Sometimes I am scared of people getting in the cab, especially in the Bronx. Some people get shot and die in the Bronx. For drugs — people do anything for drugs. You can't avoid going there. Some taxis open the window, lock the door, and ask where you going first. If I do that, I never have to go to Brooklyn, Bronx, or Queens. Most people do that. Because if you go outside Manhattan, you lose double time. You get paid to go there but come back and no pay for me.

And lots of customers every week—they run. Just open the door and go, don't pay—a lot of people are like that.

Every week one person does that. And most are long distance, like the Bronx, $40, $50 dollars you lose. Sometimes I run after them. I hit them. They never say 'sorry.' They just have to say 'I forgot my wallet' or something. Sometimes I get an excuse, and they say 'I'm so sorry,' and I say 'OK, go.' But then some just go, run. It's just bad because we lose like that. Each hour in the cab cost me about $14. Because I pay for this cab for twelve hours. It's $140 plus gas, plus MTA, plus taxes, plus a lot of stuff. So I pay $200 for this car, so I have to work seven hours for free. After that it's my money. If you cannot make $200, you lose, from my pocket I lose. This car is $900,000, almost a million, for the medallion. We lease it weekly. We pay for seven nights $930. You walk, you take-off — it's up to you. But you have to pay up front — unlike our customers."

Currently there are about twelve thousand taxicabs in New York City. The average number of rides per twelve-hour shift is thirty. Approximately 90 percent of taxi drivers aren't American born.

TAXICABS THROUGH THE YEARS

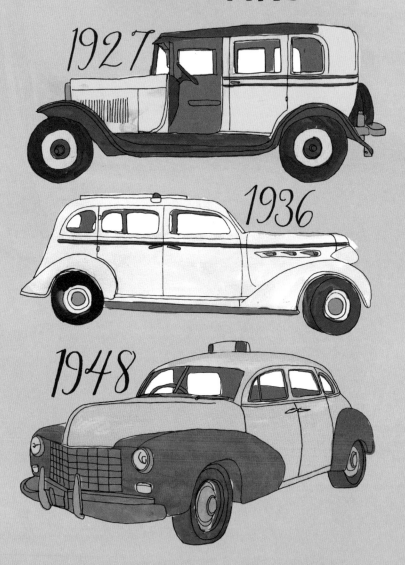

1927

1936

1948

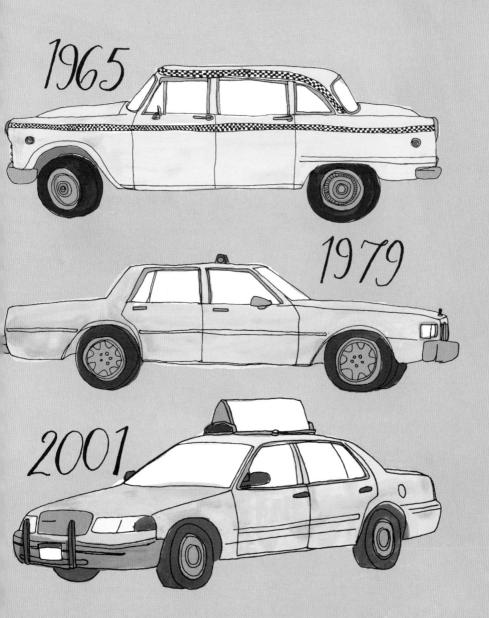

1965

1979

2001

La Grenouille

Since we've been married, my husband and I celebrate our anniversary with a one-night New York getaway. We stay at a fancy hotel in Manhattan for the night and treat ourselves to an extravagant dinner. My favorite was dining at La Grenouille, an authentic French restaurant that opened in 1962. (Don Draper and friends ate there at a meeting in Season 3 of *Mad Men*.) The restaurant is known for its lavish floral arrangements, but I just love the classic charm. Men must wear suits, and you get waited on by a captain and a server. I remember my husband chewing with his eyes closed, savoring the tastes.

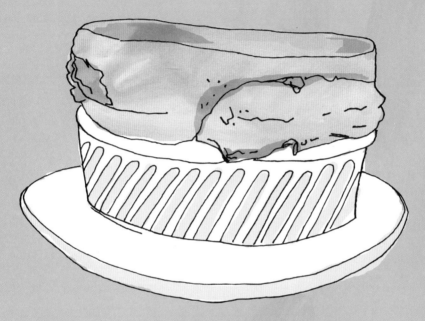

I especially took pleasure in the soufflé I had for dessert.

JEFF PORTER

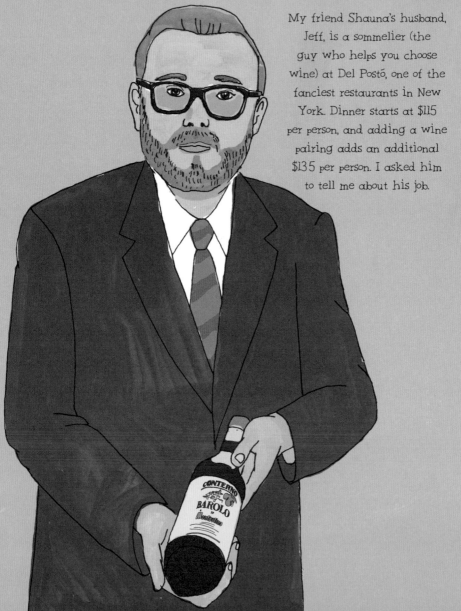

My friend Shauna's husband, Jeff, is a sommelier (the guy who helps you choose wine) at Del Postó, one of the fanciest restaurants in New York. Dinner starts at $115 per person, and adding a wine pairing adds an additional $135 per person. I asked him to tell me about his job.

"It's exciting and very stressful — guests who are paying that price have big expectations. It's a high level of intensity to provide a high level service day in and day out to guests. It's a real challenge. I wear a suit and tie. I work long days, from noon to 11:30 pm. and sometimes longer. But it's fun, because I get to taste a lot of wine. The wine list has over three thousand selections; my favorite is Barolo. Every single table doesn't ask for my help, but most do. I first ask them what they like, the flavors and tastes. Then I ask if they want to pair it with their food. Then I provide a selection based on their criteria. If they don't like it, we pull it from the table and ask what they didn't like about it so we can give them something they do like. The most expensive wine we have is a six-liter, the equivalent of eight bottles, for $12,000. I call it 'the car.'"

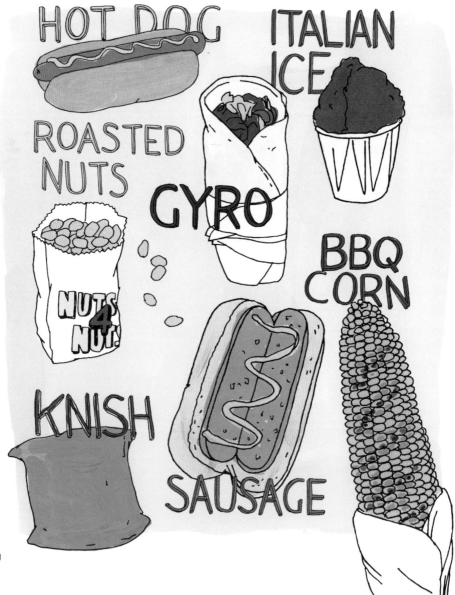

SIDEWALK SNACKS
UNDER FIVE BUCKS:

HOT DOG

ITALIAN ICE

ROASTED NUTS

GYRO

NUTS 4 NUT.

BBQ CORN

KNISH

SAUSAGE

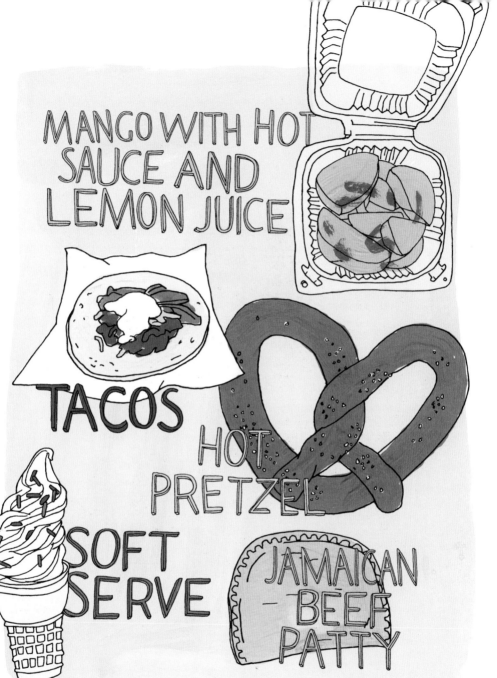

MANGO WITH HOT SAUCE AND LEMON JUICE

TACOS

HOT PRETZEL

SOFT SERVE

JAMAICAN BEEF PATTY

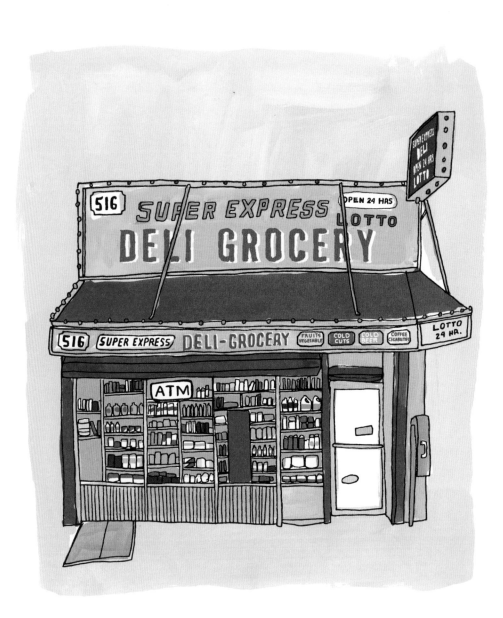

Ode TO THE Bodega

IT IS LATE AND YOU ARE GLOWING
BUZZING FLUORESCENT LIGHT
A PURRING CAT TO GREET MY LEGS
MY FEET RECOGNIZE THE SOFT CURLING LINOLEUM

YOU ALWAYS HAVE WHAT I NEED,
A TWO-PACK OF ASPIRIN
BAKING SODA FOR TOMORROW MORNING'S PANCAKES
A SCRATCH-OFF TO BRING AS A LAST MINUTE BIRTHDAY GIFT
A PLACE TO DUCK INTO WHEN I MIGHT BE GETTING FOLLOWED

I WONDER HOW MANY TIMES THE CASH REGISTER OPENED THAT DAY
HOW MANY PIECES OF GUM IT TAKES TO STAY IN BUSINESS

SOMEHOW YOU MANAGE
AND FOR THAT, I AM THANKFUL.

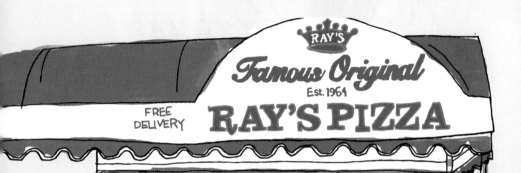

New York pizza is by far the best. There is
nothing like eating a folded greasy slice off
a piece of tissue paper and a paper plate, and
washing it down with a can of Coke.

Searching through the online White Pages,
I found over twenty pizza places with the
name Ray in the title. It has been a
tradition in New York to name your pizza
place Ray's, but many claim to be "the
original." Some places are related, but many
aren't. In case you want to compare slices,
here is a map of some of the locations:

- FAMOUS RAY'S PIZZA
- RAY'S FAMOUS ORIGINAL PIZZA
- RAY'S PIZZA
- RAY'S PIZZA BAGEL
- WORLD FAMOUS RAY'S PIZZA
- FAMOUS ORIGINAL RAY'S PIZZA
- RAY'S PIZZA RESTAURANT
- LONG WESTERN RAY'S PIZZA

Then there is the defiant
Not Ray's Pizza in
Fort Greene, Brooklyn.

It turns out the first, truly
original Ray's Pizza was
opened in 1959 on Prince
Street in Little Italy.
Sadly it closed in 2011.

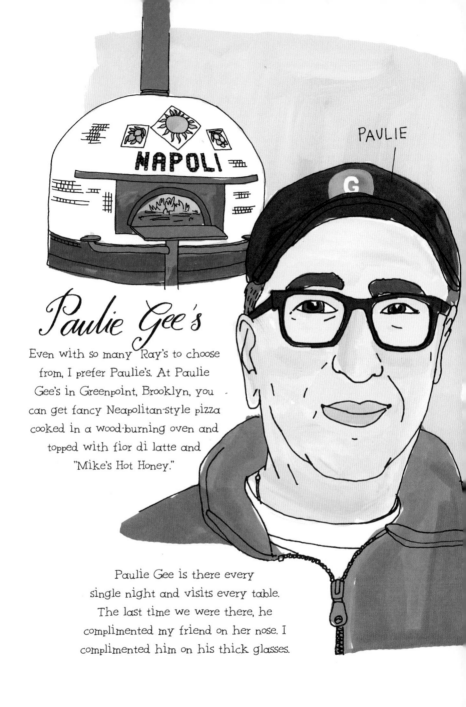

PAULIE

NAPOLI

Paulie Gee's

Even with so many Ray's to choose from, I prefer Paulie's. At Paulie Gee's in Greenpoint, Brooklyn, you can get fancy Neapolitan-style pizza cooked in a wood-burning oven and topped with fior di latte and "Mike's Hot Honey."

Paulie Gee is there every single night and visits every table. The last time we were there, he complimented my friend on her nose. I complimented him on his thick glasses.

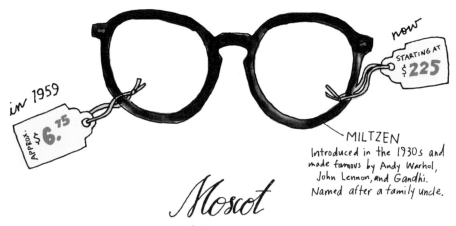

in 1959

APPROX. $6.75

now

STARTING AT $225

MILTZEN
Introduced in the 1930s and made famous by Andy Warhol, John Lennon, and Gandhi. Named after a family uncle.

Moscot

At Moscot you can find the same styles of glasses that they sold in the 1950s, which have become very stylish again. It's funny how people are wearing the same frames their parents and grandparents wore.

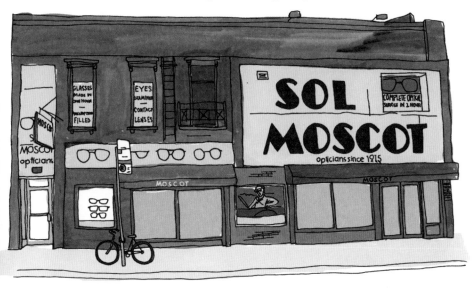

Orchard Corset

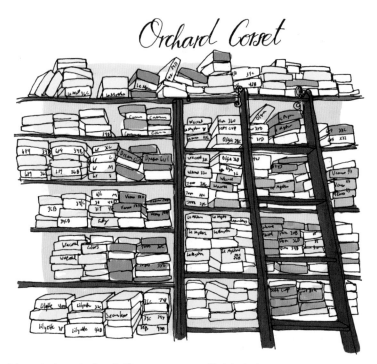

I heard that Orchard Corset was THE place to get a bra. I imagined some beautiful lingerie store. My friend and I went to check it out. With its sun-bleached sign and a tiny storefront with hardly anything in the window, you could walk right by and miss it. Inside the small shop, nothing was on display except hundreds of boxes crudely labeled with bra names like Le Mystere and Lady Marlene.

Behind the counter were a Hasidic man and woman. The woman briskly shuffled me to the back of the shop behind a curtain and told me to strip. I stood behind the curtain in my bra; she looked me up and down and declared I was a B, not a C (which I have thought I was my whole life). She thrust a new bra at me and ordered me to put it on while she watched.

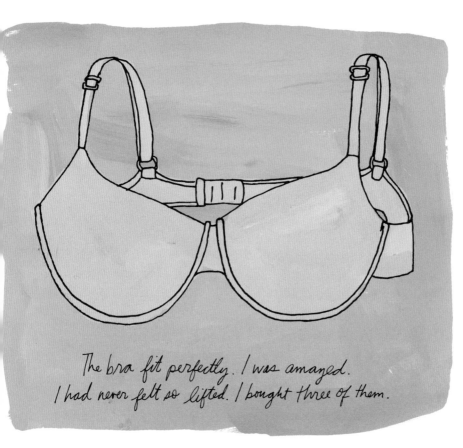

The bra fit perfectly. I was amazed.
I had never felt so lifted. I bought three of them.

While I waited for my friend to
find out her correct bra size, I
learned that the clerk makes
patterns for bras and outfitted
Madonna's world tour. Before we
left, we got a corset lesson from the
man. He was careful to not touch
our hands as he asked us to feel
the stretch of the material.

MR. STEIN

I have always been intrigued by the Hasidic Jewish community, which is prevalent in New York. My family is nonpracticing Jews, and I was never religious. Both of my Brooklyn landlords have been Hasidic Jews, and both have questioned me about why I'm not practicing. Living in a broken-down apartment with a lot of problems, I got to become very friendly with one of my landlords, who did much of the maintenance himself. As he tried to fix my leaking radiator while wearing black suit pants, a vest, and a white-collared shirt with the sleeves rolled up, he would give me advice on marriage and family and tell me stories about being a landlord. I would ask him questions about his lifestyle, his aging father, and his ten children. His children were always having a mitzvah of some kind: a Bar Mitzvah, a marriage he had arranged, or a new business venture. He told me about the eruv—the symbolic boundary marked by clear fishing wire that snakes around much of Manhattan and allows religious Jews to do things they wouldn't normally be allowed according to the law—such as carrying things from a private place to a public place or pushing a stroller. I asked him about the wig burning I had read about in the newspaper. In 2004 in Williamsburg, Brooklyn some Orthodox learned the hair in their wigs was originally from India and could have been used in Hindu ceremonies so they piled all the wigs and burned them. I walked by the charred sidewalk a few days later.

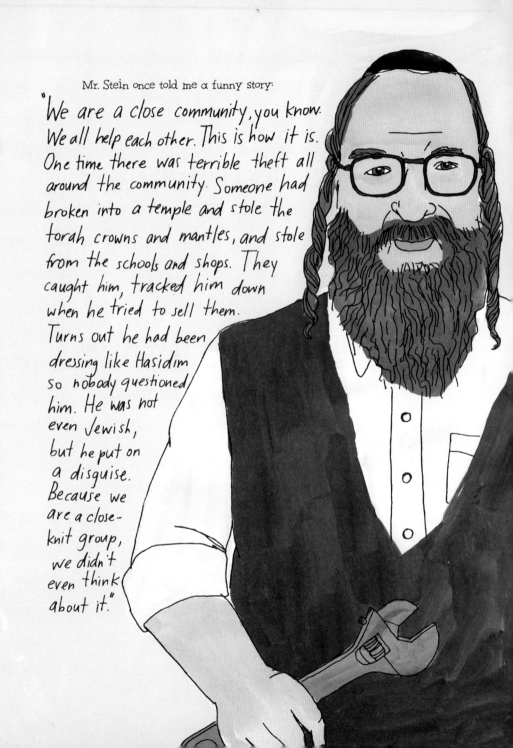

Mr. Stein once told me a funny story:

"We are a close community, you know. We all help each other. This is how it is. One time there was terrible theft all around the community. Someone had broken into a temple and stole the torah crowns and mantles, and stole from the schools and shops. They caught him, tracked him down when he tried to sell them. Turns out he had been dressing like Hasidim so nobody questioned him. He was not even Jewish, but he put on a disguise. Because we are a close-knit group, we didn't even think about it."

THE FIRST TENEMENT ACT

The First Tenement House Act, in 1867, required a window for every room of an apartment. Some apartments got away with that by cutting a "window" out of a wall that was just facing another room in the apartment. When I lived in Fort Greene, my bedroom had a window cut out into the living room, a remnant from that time. It was hard to get much privacy.

THE SECOND TENEMENT ACT

The Second Tenement House Act in 1879 changed that law and required windows to face a source of fresh air. That's when air shafts started being used.

NEW LAW

Finally the "new law" of 1901 required windows to face courtyards where there was actual moving fresh air. My apartment now has two windows that look over a small courtyard.

THE STUDIO

Apartments can be as small as 200 square feet. Most studios are just one room besides the bathroom. I've seen friends' apartments in which they were forced to sleep next to their refrigerator, because that was the only place a bed could fit. Because there isn't much space for a living room, your bed might become your couch when guests come over.

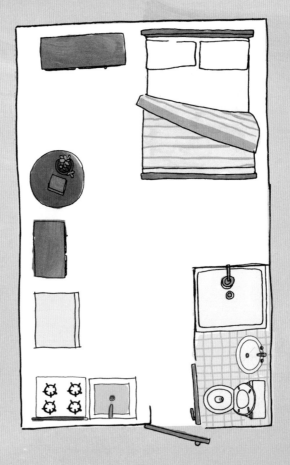

THE RAILROAD

THE TWO BEDROOM

Railroad apartments are common in New York because there are so many brownstone buildings. Each room opens up to the next in a long line, so to get to your bedroom, you might have to walk through your roommate's bedroom. Sometimes there are two entrances to help with shares.

Often you'll see a listing for a two-bedroom, and then when you go to see it, it is missing a key room, like a living room, which is being counted as the second bedroom. There's always a bit of confusion when one of the so-called bedrooms opens up to the kitchen with double glass doors, which is what I dealt with one year.

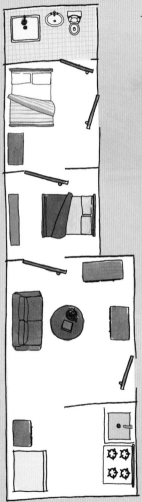

City Pests

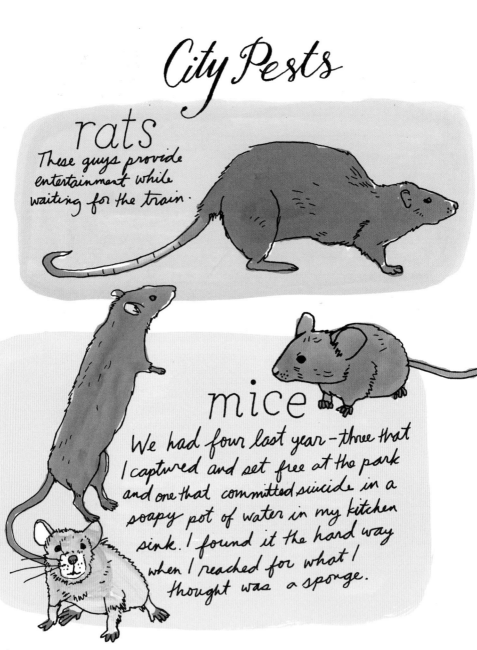

rats
These guys provide entertainment while waiting for the train.

mice
We had four last year—three that I captured and set free at the park and one that committed suicide in a soapy pot of water in my kitchen sink. I found it the hard way when I reached for what I thought was a sponge.

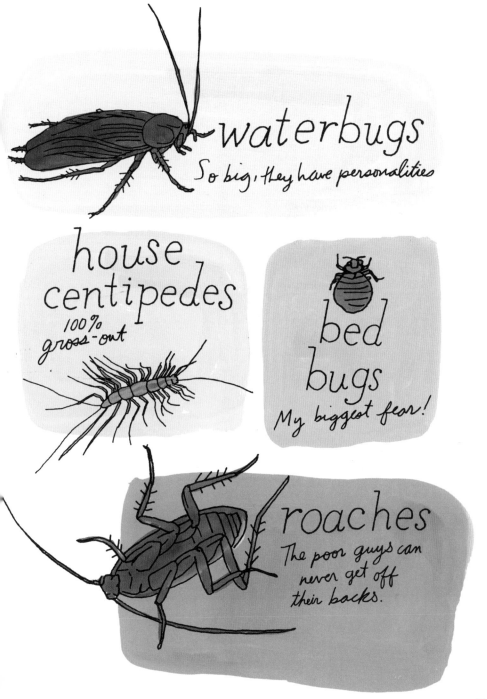

waterbugs
So big, they have personalities

house
centipedes
100%
gross-out

bed
bugs
My biggest fear!

roaches
The poor guys can
never get off
their backs.

City Pets

Stray cats often find homes in bodegas and bookstores and help with the pest problems.

Apartment cats never get to explore the outside world except by sitting in the window and looking out.

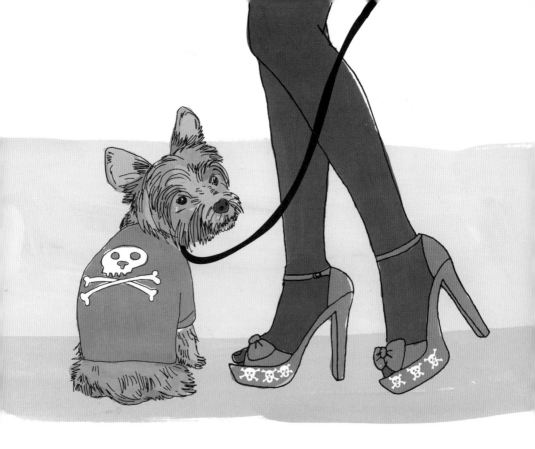

Dogs in New York are often pampered. They are carried around in bags on the subway. There are dog spas, hotels, and day care facilities, and you'll often see a small dog dressed as well as its owner.

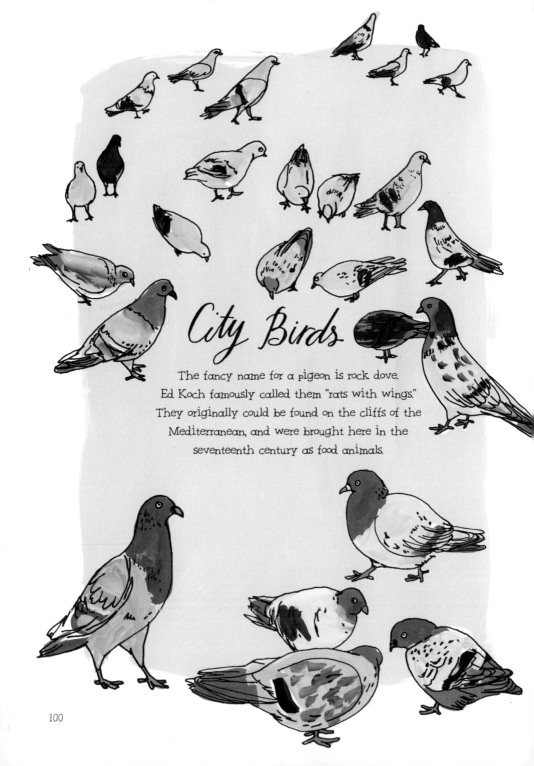

City Birds

The fancy name for a pigeon is rock dove.
Ed Koch famously called them "rats with wings."
They originally could be found on the cliffs of the
Mediterranean, and were brought here in the
seventeenth century as food animals.

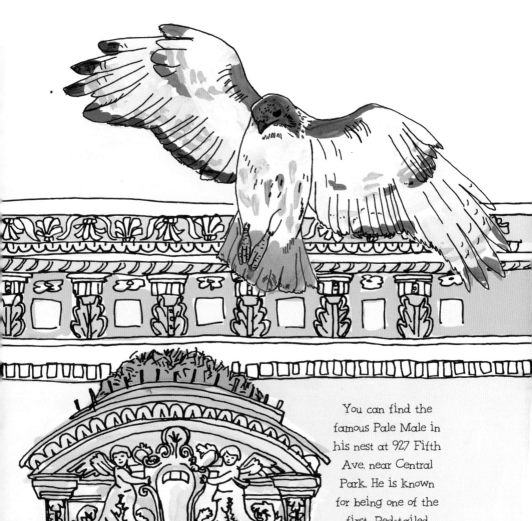

You can find the famous Pale Male in his nest at 927 Fifth Ave. near Central Park. He is known for being one of the first Red-tailed Hawks to nest in a building rather than a tree. He feeds on pigeons and rodents.

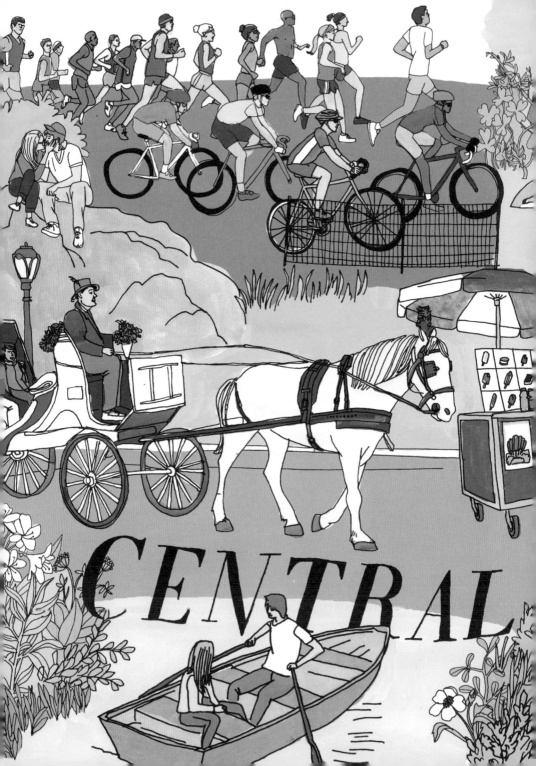

CENTRAL

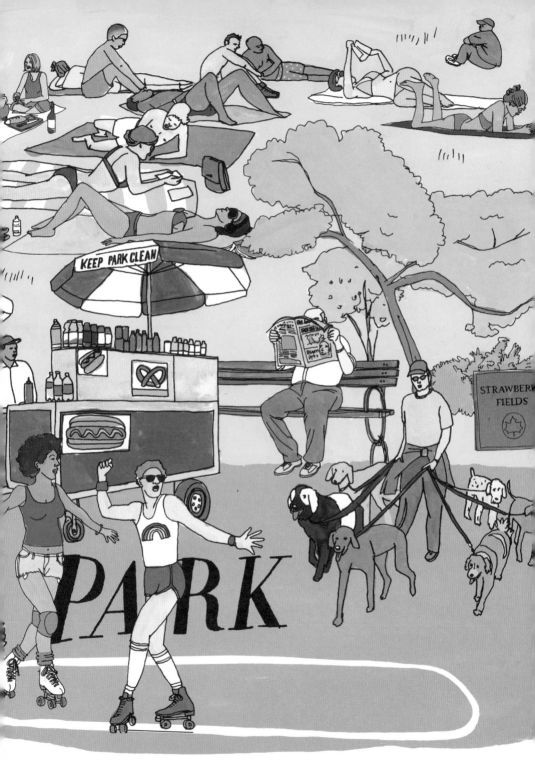

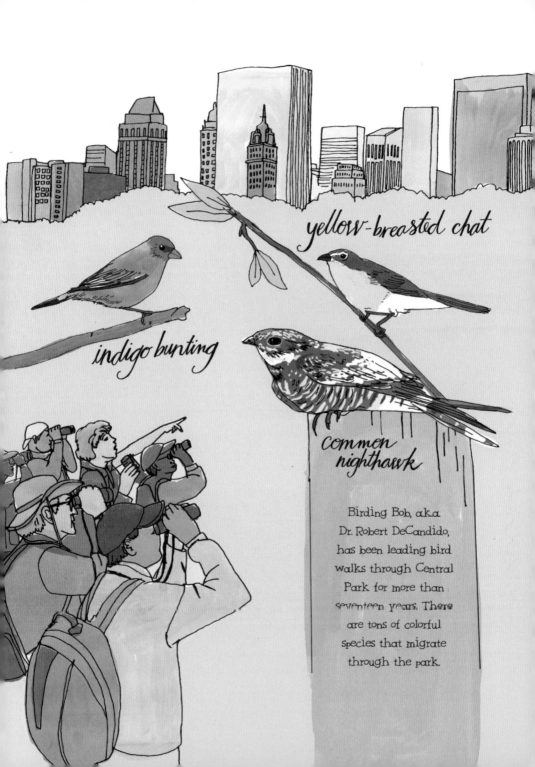

yellow-breasted chat

indigo bunting

common nighthawk

Birding Bob, a.k.a.
Dr. Robert DeCandido,
has been leading bird
walks through Central
Park for more than
seventeen years. There
are tons of colorful
species that migrate
through the park.

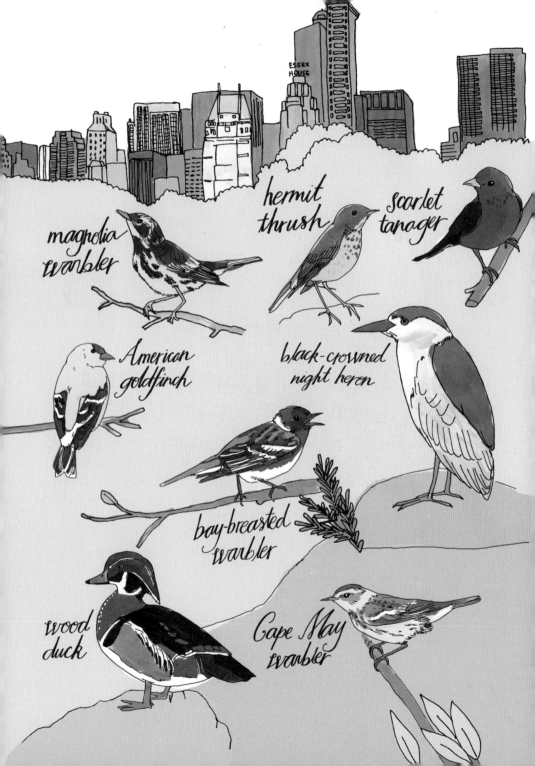

magnolia warbler

hermit thrush

scarlet tanager

American goldfinch

black-crowned night heron

bay-breasted warbler

wood duck

Cape May warbler

ESSEX HOUSE

Bronx Zoo

Central Park has a small zoo, but nothing can compare to the incredible Bronx Zoo, one of the world's most famous zoos. There are more than six hundred species from around the world. As a kid, I loved the children's zoo, where you can stick your head up through holes in the ground and wave to your mother, surrounded by prairie dogs.

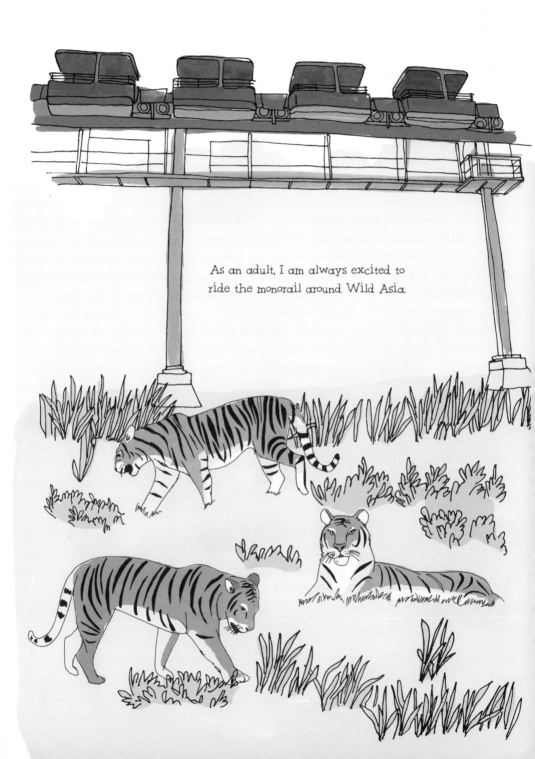

As an adult, I am always excited to ride the monorail around Wild Asia.

Arthur Avenue

After the zoo, it's my family's tradition to walk to Arthur Avenue, the Little Italy of the Bronx, for some Italian treats. There are lots of pastry shops, cafés, wine shops, pasta shops, and charcuteries. There is always the option for some delicious gelato.

ESPOSITO'S SOCIAL CLUB

Italian love songs, opera music, and Frank Sinatra favorites can be heard blasting from the restaurant kitchens.

Broadway

When tourists come to New York, seeing a Broadway show is often on the top of their lists. While it seems like a very New York thing to do, people who live here don't go to see shows that often. My childhood ballet and jazz teachers all were former Broadway-show performers. But out of the twenty longest-running Broadway shows, I've only seen four: *The Phantom of the Opera, Cats, Les Miserables,* and *Rent* (5 times).

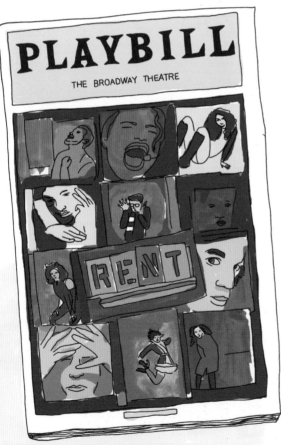

I was in high school when the Broadway show *Rent* opened, and I am a bit embarrassed to admit that my friends and I became obsessed. We learned there were first-come, first-served $20 tickets for seats in the first two rows of every performance. But this was a popular show, so the only real way to do it was to get there very early in the morning to beat the other fans. Two of my friends and I thought we were smart and decided that

instead of showing up in the morning, we would sleep outside the box office on the sidewalk so we would be the first people there. We arrived around 9p.m. to quickly learn we weren't the most clever or the biggest fans. Apparently there was a ragged group of teenagers who slept there almost every night who called themselves Rent-heads. We set up sleeping bags on the concrete anyway, in a row behind about twelve other people. For us, at sixteen, it was an adventure just to be in the middle of the city when it was so dark out. Coincidentally, it also happened to be Fleet Week, so we were entertained by scores of sailors walking around partying. Eventually a few stumbled upon the three of us, and they wound up hanging out with us on the sidewalk talking until the late hours of the night. There may have been some making out. We didn't wind up seeing the performance that next day because there were too many people ahead of us. Instead, we ended up like characters in the show, eating breakfast in Washington Square Park, dirty, tired, and still singing "Seasons of Love."

145 E. 37th St., Manhattan

The Manhole Cover Lady

Historian Diana Stuart has been nicknamed "The Manhole Cover Lady." She has located and documented over 400 manhole covers in New York City and made me aware of the beauty and history that can be found underfoot.

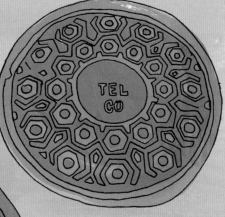

6th Ave. at Garfield Pl., Brooklyn

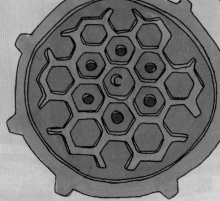

16th St. at Prospect Park Southwest, Brooklyn

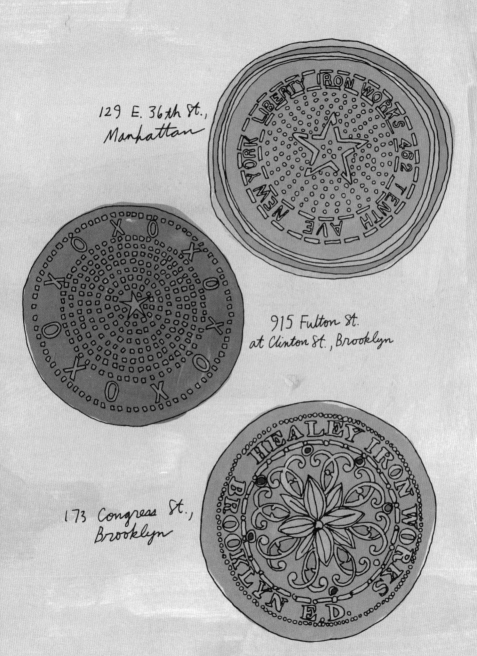

129 E. 36th St.,
Manhattan

915 Fulton St.
at Clinton St., Brooklyn

173 Congress St.,
Brooklyn

113

114

Sometimes I look at the sidewalk and have to remind myself that all those black circles are someone's dirty, discarded chewing gum.

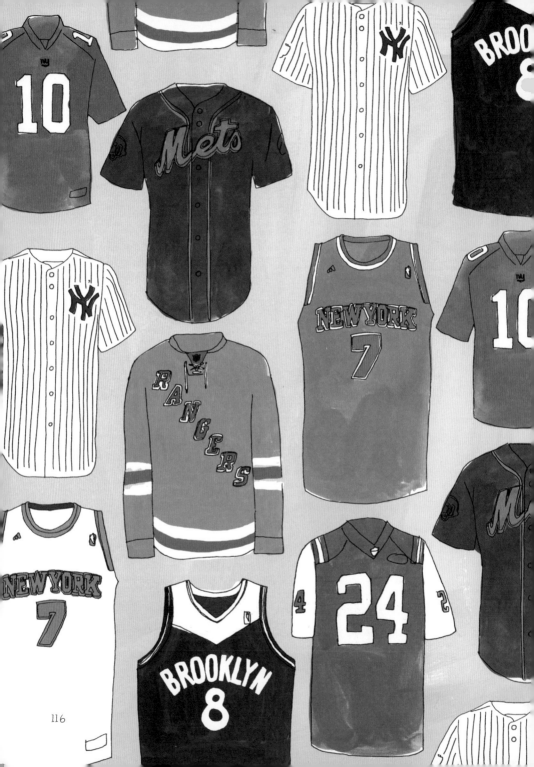

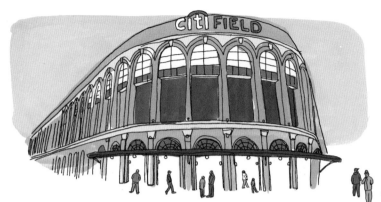

My husband loves baseball, so I get dragged to a few games every summer. He is a St. Louis Cardinals fan, so whenever they play the Mets we take the long subway ride out to Citi Field. I am always torn about my loyalty, though. I root for the Mets over the Cardinals, of course, but having grown up in the Bronx, I'm a Yankees fan at heart. It's funny taking the subway to a game, because as you get closer and closer to the stadium, you realize that every person in the subway car is going to the game with you. Strangers start conversations about players, and my husband gets some teasing for rooting for the wrong team. But the most satisfaction comes when I can order my veggie dog at the stadium and fill it with sauerkraut and mustard. After the game, the train car is filled with excitement and drunken people. They are still cheering and chanting, and my husband is sulking in his seat. Let's go Mets!

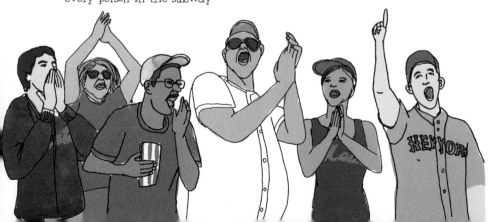

CONEY ISLAND

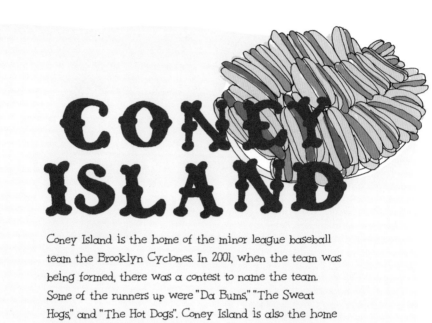

Coney Island is the home of the minor league baseball team the Brooklyn Cyclones. In 2001, when the team was being formed, there was a contest to name the team. Some of the runners up were "Da Bums," "The Sweat Hogs," and "The Hot Dogs". Coney Island is also the home to the original Nathan's Famous, which hosts the annual Fourth of July Hot Dog Eating Contest. In 2012, Joey Chestnut ate sixty-eight hot dogs and buns in ten minutes, winning him a trophy, two cases of Nathan's hot dogs (because he hadn't eaten enough hot dogs yet!), and a nice cash prize.

Coney Island also celebrates its beach every year by organizing a Mermaid Parade. Participants dress up in homemade costumes that celebrate the mythology of the sea. Most commonly, people dress as mermaids and mermen, sea creatures, pirates, striped-shirt sailors, and Neptune. There are lots of seashell bikinis, pasties, sparkles, pearls, body paint, colorful wigs, and crowns. Mermaids with tails get wheeled on a chariot. Every year a celebrity King Neptune and Queen Mermaid (David Byrne, Moby, and Queen Latifah are some of the notable ones) do a traditional ribbon cutting and toss fruit into the water for the sea gods. It is hot and the beach is crowded, but it's a day full of spirit and a celebration of summertime.

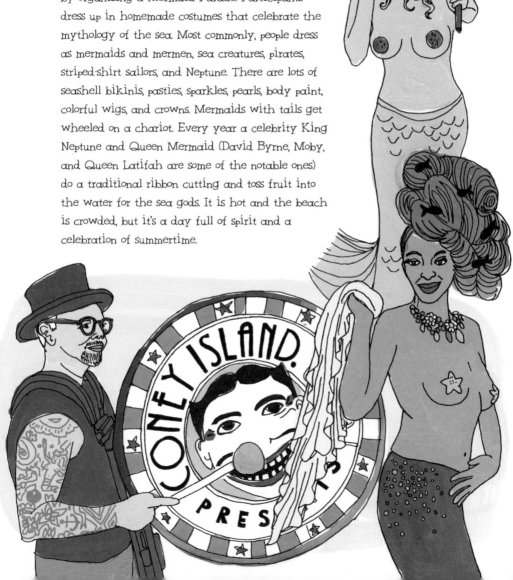

Dead Horse Bay AKA BOTTLE BEACH

Dead Horse Bay is an inlet at the southwestern end of Floyd Bennett Field in Brooklyn. In the 1800s, it surrounded what was then Barren Island, home to garbage incinerators and glue and fertilizer manufacturers. It got its name because dead horses were used in the glue and fertilizer processing. In the 1920s, the stench was so bad that the city shut down the factories and used garbage as fill to connect the island to the mainland. In the 1950s, one of the caps on a landfill container burst open, sending garbage all over the beach, which is still covered in trash.

While it sounds gross, it's actually quite intriguing. Glass bottles and pieces of bottles of all shapes and sizes from many decades ago fill the beach, some with their vintage labels still intact. Rusted metal pieces; old, classic-looking shoe soles; and tiny jars are also common. More disturbing are the horse bones you come across every few yards. As the tide recedes, an eerie tinkling can be heard as broken glass pieces hit each other in the water. I recently took a trip there with an artist friend who collected three bags full of stuff he found on the beach to use in his sculptures. Some of the things I took home:

a Mission Beverages bottle

mission BEVERAGES *naturally good*

its up to you

a tiny mug

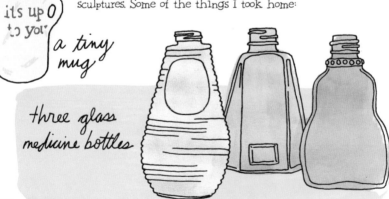

three glass medicine bottles

120

a decorative knob

a metal toy tire

a small cluster of hexagon tiles

half a pair of eyeglasses

a piece from a porcelain three-pole switch from the electrical supply company Leviton (There were tons of these everywhere. It took a lot of internet searching to figure out what it was.)

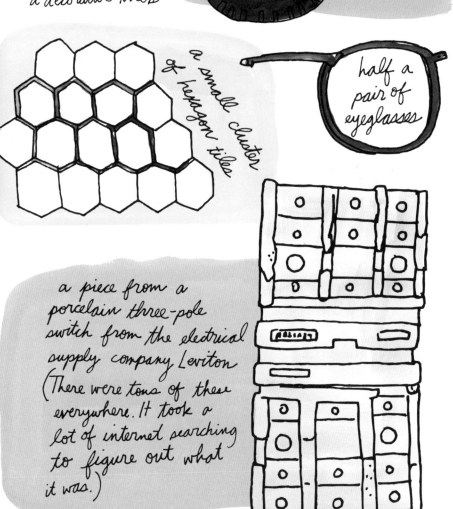

Melinda Beck, an illustrator friend of mine, takes advantage
of places in New York to swim, including the East River:

MELINDA BECK

"I practice open water swimming with a group called the Coney Island Brighton Beach Open Water Swimmers. We swim a three-mile loop from the east end of Brighton Beach to the Coney Island pier and back, parallel to the shore about fifty yards from the beach. The farthest I have swum is a four-person relay around Manhattan Island. I did seven miles of a twenty-eight-mile course. I am in the ocean all year round. The best

winter swim I ever did was during the blizzard in 2009. Except for the other swimmers, the beach at Coney Island was completely deserted—white beach covered in snow, silver sky, and a matching silver ocean. The only color in the Arctic landscape was the defunct amusement ride, the red Parachute Drop, barely visible in the falling snow. In 2009, I did the twelve required winter swims and earned my Polar Bear patch.

The coldest water I swam in was 32 degrees out at Coney Island. I lasted 10 minutes. The hardest part of swimming in the water is the long, cold walk down the beach. I wear a watch and pool thermometer so I can judge when it is

When it comes to getting in the water, I just do it: going in slow is worse. As I swim, my hands and feet feel numb, and sometimes I get a warm sensation all over, like when you drink alcohol.

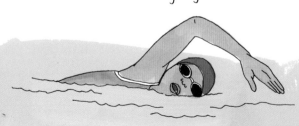

time to get out based on the temperature. Once it is time to get out, my body has adjusted to the temperature, and I have about ten minutes to get up the beach and dressed before I start shivering.

Pools are all the same: same water temperature, same size, same black line. But with oceans and rivers, you never know what you are in for: big waves over your head, smooth as a mirror, a fight against the current the whole way, or the current going with you so buildings just fly by.

Sometimes the water is so clear at Coney Island, I can watch the crabs crawl around the sea floor twenty feet below me while I swim.

The thing that scares me most is not the current or the jellyfish that appear in droves in August, but jet skiers. We wear brightly colored caps so they can see us, but they come close to shore, go fast, and still make me nervous. The water is cleaner than you think. I was in the East River last week up to my waist and I could see my feet."

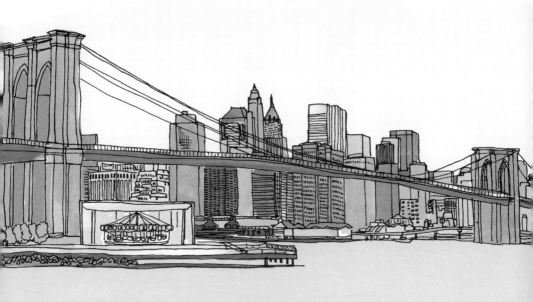

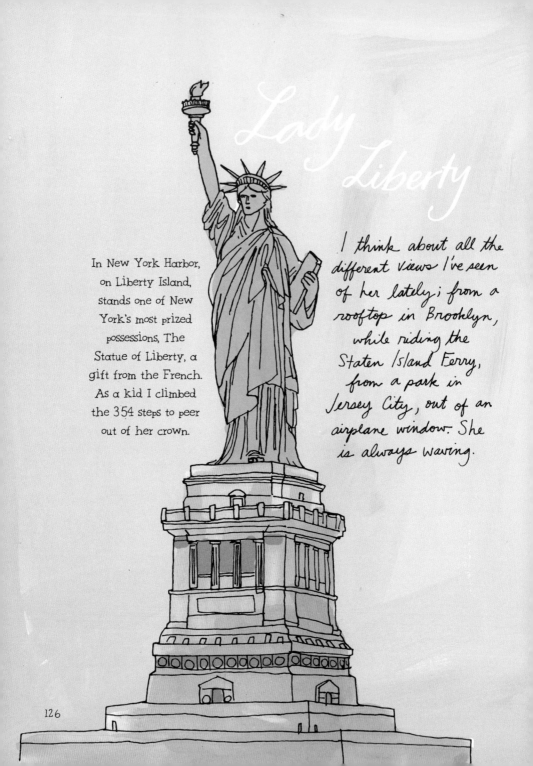

Lady Liberty

In New York Harbor, on Liberty Island, stands one of New York's most prized possessions, The Statue of Liberty, a gift from the French. As a kid I climbed the 354 steps to peer out of her crown.

I think about all the different views I've seen of her lately; from a rooftop in Brooklyn, while riding the Staten Island Ferry, from a park in Jersey City, out of an airplane window. She is always waving.

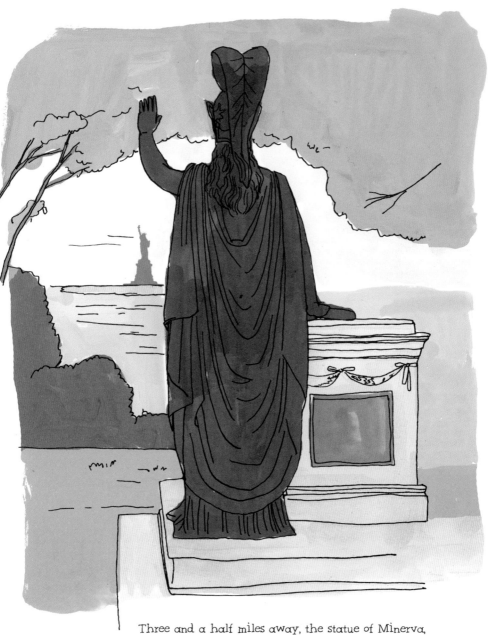

Three and a half miles away, the statue of Minerva,
the Roman goddess of wisdom, waves back at Lady
Liberty from Green-Wood Cemetery in Brooklyn.

ALICE SPITALNIK

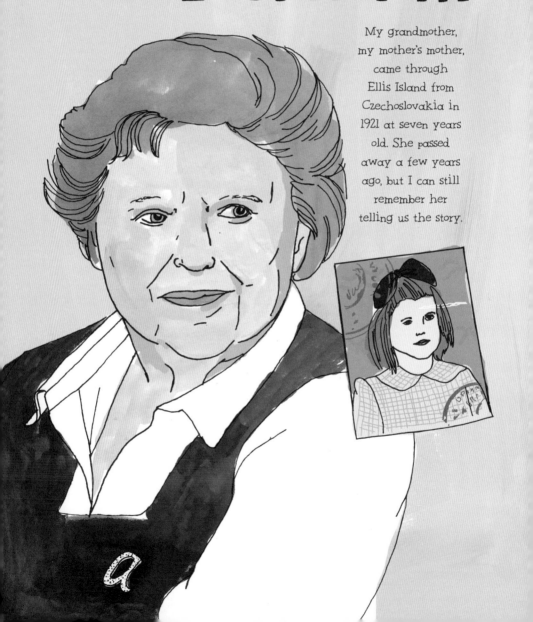

My grandmother, my mother's mother, came through Ellis Island from Czechoslovakia in 1921 at seven years old. She passed away a few years ago, but I can still remember her telling us the story.

"My father went to America to find a new life for my mother and the seven children. My mother died, though, and so my father sent for us. He shipped us a box filled with yards of black-and-white calico fabric so we could have new dresses. With my cousin and a chaperone, my sisters and I rode the train to Prague and then another to Antwerp, Belgium, where we boarded The Finlandia and set off across the Atlantic Ocean. It took four weeks, but I had my doll and we played games. I didn't remember my father, because he had left for America when I was a baby, and he couldn't return because of World War I. When we arrived, we were shuffled into a big room and then each of us was taken to a smaller room to be examined. Next we waited on a bench and someone passed out milk and cookies. Then our name was called —Friedman!—and we ran to the gate and our father hugged us. I could see tears in his eyes."

I lost my first tooth, and I threw it overboard into the ocean for good luck.

Ellis Island

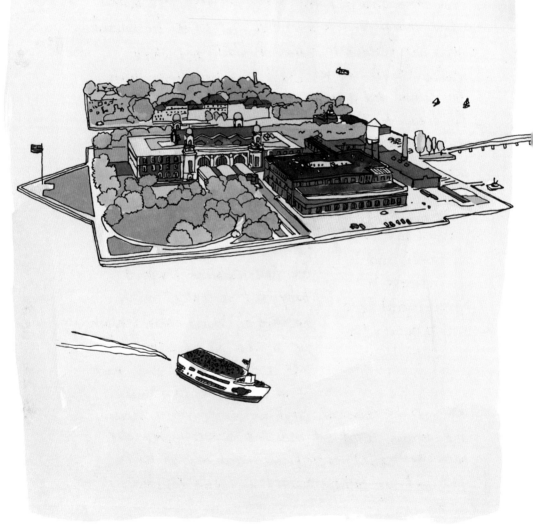

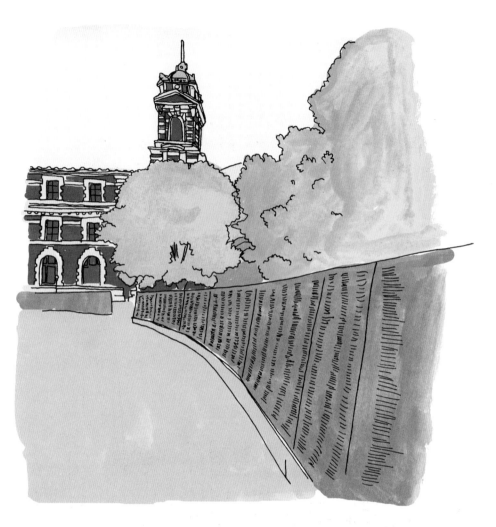

My parents and I went to Ellis Island
and they showed me her name on the
American Immigrant Wall of Honor. There
are more than 700,000 names inscribed.

From Ellis Island you get a great view of downtown Manhattan. Standing so far away from it, it doesn't look real. It could be a still from hundreds of movies, an image on thousands of postcards, the background to millions of snapshots.

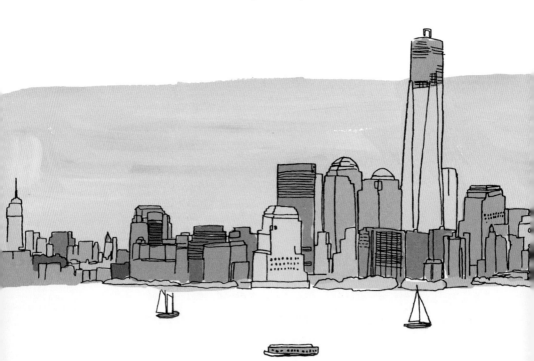

I think about all the people rushing around inside all of those buildings and up and down the streets, the lanes of taxis filled with passengers, the screeching of subway car brakes and the shuffling toward the door. Suddenly I feel the pull and want to hurry back onto the ferry that will take us back so I can be in the middle of it again.

ADDRESSES
+NOTES

PGS. 8-11

Getting to City Island: Take the 6 train to the last stop, Pelham Bay. Take the Bx29 bus to City Island. On weekdays at rush hour there is a comfortable bus - the BxM8 express bus from Manhattan - that takes you all the way there .

For eats on the island:

The Black Whale, 279 City Island Avenue, good for lunch

The City Island Diner, 304 City Island Avenue, classic small diner

Johnny's Reef, 2 City Island Avenue, fried fish on the water

Artie's Steak and Seafood, 394 City Island Avenue, classic Italian dinner

Visit:
Orchard Beach: You can walk over the City Island bridge along the beach to get there or drive off the island and follow the signs.

PGS. 16-17

Katz's Delicatessen, 205 E. Houston Street

Russ and Daughters, 179 E. Houston Street

Yonah Shimmel Knish Bakery, 137 E. Houston Street

Economy Candy, 108 Rivington Street

These are also good treats close by:

Donut Plant, 379 Grand Street, so many delicious flavors. They sell fast so go early.

Vanessa's Dumpling House, 118A Eldridge Street, super cheap and delicious! Get the dumplings and you get whole meal for under $5.

The Pickle Guys, 49 Essex Street, hole-in-the-wall filled with giant vats of pickles of every flavor.

PGS. 18-19

Park Slope favorite eats:

Blue Ribbon, 280 5th Avenue, for oysters and #1 Bloody Mary's

Talde, 369 7th Avenue, try the crazy shaved ice dessert with Cap'n Crunch

Thistle Hill Tavern, 441 7th Avenue, cozy bar restaurant

Zito's Sandwich Shoppe, 300 7th Avenue, for great sandwiches

Applewood, 501 11th Street, for brunch

For fun:

The Bell House, 149 7th Street, for music and comedy shows

Union Hall, 702 Union Street, for bocce and beer and basement comedy shows

Skylark Bar, 477 5th Avenue, for drinks and trivia

Prospect Park, 585-acre park, 30,000 trees, dog beach, organized sports, free concerts

PGS. 22-23

Check out the newly restored Peep-O-Rama sign run by the Times Square Alliance, 1560 Broadway, between West 46th and 47th Streets

PG. 30

Grand Central Station, 87 East 42nd Street

Also check out the Grand Central Oyster Bar inside the station

PG. 34

New York Public Library Main Branch, 11 W. 40th Street

Also check out the Picture Collection at the Mid-Manhattan Branch across the street for hundreds of folders of images from periodicals by subject. It is like an analog Google image search.

PG.42

"Alamo," Astor Place traffic island at Lafayette and 8th Streets

"The Passage," South end of Union Square Park at 14th Street

Some runners up for great public art:

"Sol Le Witt's installation in the 59th Street Columbus Circle subway station

"Adam and Eve," Botero sculptures at Time Warner Center, 10 Columbus Circle

"Atlas," Rockefeller Center, 630 Fifth Avenue

PGS.44-59

Metropolitan Museum of Art, 1000 5th Avenue

The Natural History Museum, 200 Central Park West

The Museum of Modern Art, 11 West 53rd Street

The Guggenheim, 1071 5th Avenue

Lower East Side Tenement Museum, 103 Orchard Street

Intrepid Sea Air and Space Museum, West Side Highway at 46th Street

The Queens Museum of Art New York Avenue, Flushing Meadows, Corona

The Cloisters Museum & Gardens, 99 Margaret Corbin Drive

Museum of the Moving Image, 36-01 35th Avenue, Astoria

New York Transit Museum, Boerum Place, Brooklyn

The Lower East Side Troll Museum, 122-24 Orchard Street #19 (by appointment)

The New York Tattoo Museum, 203 Old Town Road, Staten Island

PGS.60-63

Fort Wadsworth, Staten Island

Frank Lloyd Wright House, 48 Manor Court, Lighthouse Hill, Staten Island

The Jacques Marchais Museum of Tibetan Art, 338 Lighthouse Avenue, Staten Island

PG. 65

Flushing Mall, 133-31 39th Avenue, Flushing

Golden Mall, 41-28 Main Street, Flushing

Spa Castle, 131-10 11th Avenue, Flushing

PG. 68

Omonia Cafe, 32-20 Broadway, Astoria

Uncle George's Greek Tavern, recently closed. Instead try Bahari Estiatorio for good Greek food, 3114 Broadway, Astoria

Visit

The Noguchi Museum, 9-01 33rd Road, Long Island City

Socrates Sculpture Park, 3205 Vernon Boulevard, Long Island City

PGS. 76-79

La Grenouille, 3 East 52nd Street

Del Posto, 85 10th Avenue

PGS. 86-89

Paulie Gee's, 60 Greenpoint Avenue

Moscot, 118 Orchard Street

Orchard Corset, 157 Orchard Street

I haven't done this but it looks cool:

Jewish Hassidic Walking Tour guided by Rabbi Beryl Epstein, www.jewishtours.com

PG. 101

Check out www.palemale.com for daily images of the Red-tailed Hawk.

PGS.104-105

To take a walk with Birding Bob, check his site www.birdingbob.com

To take birding tour of Pelham Bay Park, check out my dad's site at

www.cityislandbirds.com

PG.106

Bronx Zoo, 2300 Southern Boulevard, Bronx

PGS.108-109

Arthur Ave. around 187th Street, Bronx

Some places to check out:

Addeo & Sons Bakery, 2372 Hughes Avenue, Bronx

Egidio Pastry Shop, 622 E. 187th Street, Bronx

De Lillo Pasticceria, 610 E. 187th Street, Bronx

Borgatti's Ravioli & Egg Noodles, 632 E. 187th Street, Bronx

Casa Della Mozzarella, 604 E. 187th Street, Bronx

Arthur Avenue Retail Market, 2344 Arthur Avenue, Bronx

PGS.112-113

Check out Diana Stuart's book, **Designs Underfoot: The Art of Manhole Covers in New York City** for more

PG.116

Citi Field, 123-01 Roosevelt Ave, Flushing

PGS.118-119

On Coney Island, check out:

Nathan's Famous, Corner of Surf and Stillwell Avenue, Brooklyn

New York Aquarium, 602 Surf Avenue, Brooklyn

Walk to Brighton Beach

For more on the Mermaid Parade, check out www.coneyisland.com/mermaid.shtml

PG.120

Dead Horse Bay, directly across Flatbush Avenue from the main entrance to Gateway National Recreation Area and Floyd Bennett Field.

PGS.122-124

Coney Island Brighton Beach Open Water Swimmers, www.cibbows.org

PG.127

Green-Wood Cemetery, Willow Avenue, Brooklyn
Minerva is located on Battle Hill in front of Higgins' Tomb

PGS.130-133

Ellis Island, www.ellisisland.org

For lots of good exploring ideas, check out
www.forgotten-ny.com

Thank You

To my editor and friend, Bridget Watson Payne, for always believing in my projects and being patient, thoughtful and constantly reassuring. To Christina, Brooke, Kate, Kristen and all the other amazing people I get to work with at Chronicle Books. To my parents for raising me in the #1 city and always being supportive, encouraging and loving. To my sister who is always a NYer no matter what country she is in. To Jenny and Matt for being my forever collaborators, harshest critics and best friends. To Matty, my love, for putting up with my NY attitude and sharing so many bagel breakfasts with me. To Shauna for going on so many NY adventures with me and giving me so many great ideas for the book. To friends Liz, Jess, Grace, Dave, Abi, Jessie, Andy, Caitlin, Civi and my ladies Rachael and Leah for letting me lean on you. xoxo